CUNARD

THE MOST FAMOUS OCEAN LINERS IN THE WORLD™

Japanese Woodblocks
Masterpieces of Art

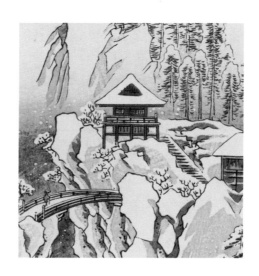

Publisher and Creative Director: Nick Wells
Project Editor: Esme Chapman
Picture Research: Esme Chapman
Art Director: Mike Spender
Layout Design: Nick Wells
Copy Editor: Ramona Lamport
Proofreader: Dawn Laker

Special thanks to: Catherine Taylor and Laura Bulbeck

FLAME TREE PUBLISHING
Crabtree Hall, Crabtree Lane
Fulham, London SW6 6TY
United Kingdom

www.flametreepublishing.com

First published 2014

14 16 18 17 15
3 5 7 9 10 8 6 4 2

Image credits: © **Artothek and the following contributors:** Christie's Images Ltd 61, 65, 66, 72, 74, 75, 77, 107,
108, 113, 114, 115, 117, 124; Peter Willi 63; Stiftung Museum Kunstpalast 50, 90, 92, 94, 95, 96, 97, 99,
100–101, 102; © **Bridgeman Art Library:** 22, 28, 58–59, 64, 67, 70–71, 106 **and the following contributors:**
Arthur M. Sackler Gallery, Smithsonian Institution, USA/The Anne van Biema Collection 84; Christie's Images 69
The Trustees of the Chester Beatty Library, Dublin 62; © **Superstock:** 125 **and the following contributors:**
Bridgeman Art Library, London 68; Buyenlarge 38, 111, 120, 122; Christie's Images Ltd. 44–45, 52, 73, 76;
DeAgostini 39, 41, 42, 48, 51, 79, 82, 88, 91, 103; Fine Art Images 23, 29, 30, 36, 37, 43, 46, 47, 49, 57,
60, 109, 110, 112, 116, 118, 119, 121, 123; Image Asset Management Ltd. 34, 40, 53, 56, 78, 93; Interfoto
31, 32, 33, 35, 83, 85, 86, 87, 89, 98.

Hardback ISBN 978-1-78361-212-3
Paperback ISBN 978-1-78361-281-9

Printed in China

Japanese Woodblocks
Masterpieces of Art

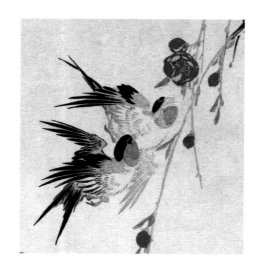

Michael Robinson

**FLAME TREE
PUBLISHING**

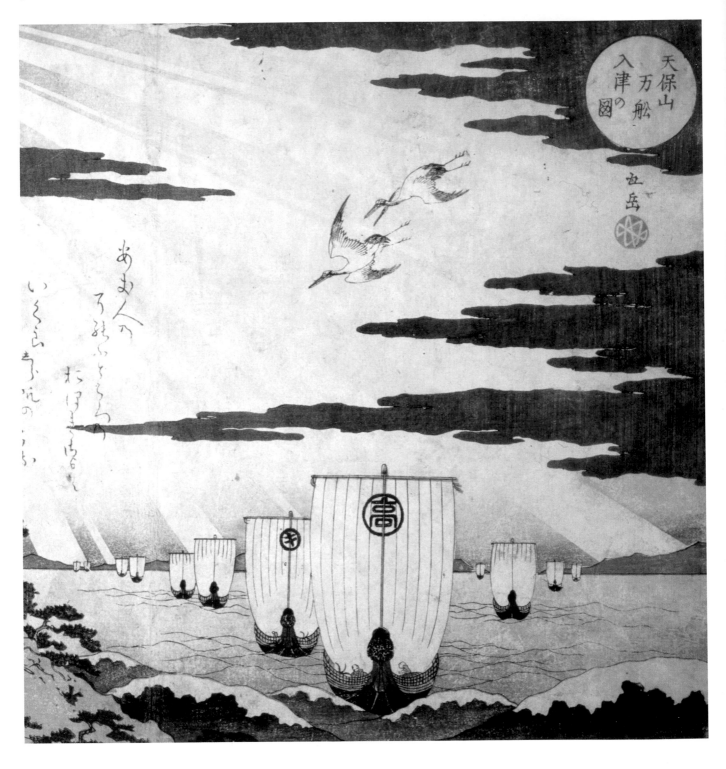

Contents

Woodblocks:
The Art of Pleasure

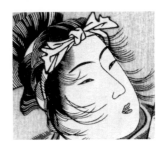

In the West we consider the production of art as a reflection of the society in which it is created. Japanese art is no different and this was perhaps part of the appeal of its aesthetic to European artists in the nineteenth century, who were inspired by the simplicity of design and compositional aspects of the *ukiyo*, or 'floating world' of Japanese society in the Edo period (1603–1867). The *ukiyo* was originally a Buddhist term that referred to sorrow, or pain, but in the seventeenth century, it came to symbolize the pleasure-seeking lifestyle of the middle classes. Depictions of this culture became known as *ukiyo-e*, images made in an ancient Eastern tradition of woodblock printing using water-based colour that evoked the hedonism of the Edo period.

Precursors to the Edo Period

Prior to 1603, the samurai class of warriors ruled Japan, with the emperor having limited executive power after the thirteenth century. As head of the samurai, and thus the military commander, the shogun was the de facto ruler of Japan. Between 1573 and 1603, there was no shogunate, as Japan fought a civil war, led mainly by the dissatisfied *daimyo*, or feudal lords, who controlled about 300 Japanese territories, or regions. It was Tokugawa Ieyasu (1543–1616), a samurai himself, who finally seized power in 1603, becoming shogun and marking the beginning of the Tokugawa Shogunate, which continued until 1867. The Tokugawa period is also known as the Edo period, when Edo (now Tokyo) became the centre of government (the *bakufu*) in Japan.

The Edo Period and its Culture

This period marked a key shift in foreign policy, when Shogun Ieyasu closed the trading doors to the outside world with very few exceptions. Not only was it forbidden for Japanese nationals to leave the country, most foreign nationals were barred from entry to Japan. The shogunate

issued these rules partly to suppress Christian (Catholic) missionary doctrine in Japan, but mainly to control all European influences that he considered had caused a destabilizing effect in the country. In essence, the only trade allowed was through the port of Nagasaki, and the only Europeans allowed in or out were the Dutch East India Company. This isolationist policy, in which Japan shut itself off from the rest of the world, had a stabilizing effect on the country, leading to a burgeoning economy for the new shogunate.

Culture of Edo in the Seventeenth Century

As Edo was a new city, it had no culture of its own in the early seventeenth century, and so was influenced by Kyoto and Osaka, the two major cities in Japan at the time. Aside from the emperor and the nobles, society was divided into a hierarchy with the samurai (the warrior class, who were loyal to the shogun) at the top, followed – surprisingly – by the peasants (about 80 per cent of Japan's population, since its economy at this time was heavily agrarian), who in turn were followed by the artisans and finally the merchants. However, the merchants became very wealthy during the Edo period and consequently became the consumers of a hedonistic lifestyle in Japan, as they were unable to use their wealth for political enhancement due to the strict social hierarchy imposed by the shogunate.

Prior to the Edo period, the government capital was Kyoto, where the emperor also had his palace. In a break from tradition, Shogun Ieyasu chose the small town of Edo as the centre of his administration, although the emperor continued to live in Kyoto. During the Edo period, the strict social hierarchy was controlled by a mix of Confucianism and Zen Buddhism, and the samurai class was expected to be educated, sophisticated and wise. Although the country became prosperous, the 'natural order' became inconsistent with the aspirations of the bourgeoisie after they had become wealthier and more influential.

A defining moment in this challenge to the social order occurred in 1657, when a huge fire destroyed the castle and much of the town of Edo. Rather like the citizens of Paris some 200 years later, the city was rebuilt around a new culture, the centre of which was bourgeois, the bourgeoisie being the wealthy merchants. This bourgeois class enjoyed the relative peace and prosperity afforded by the new regime,

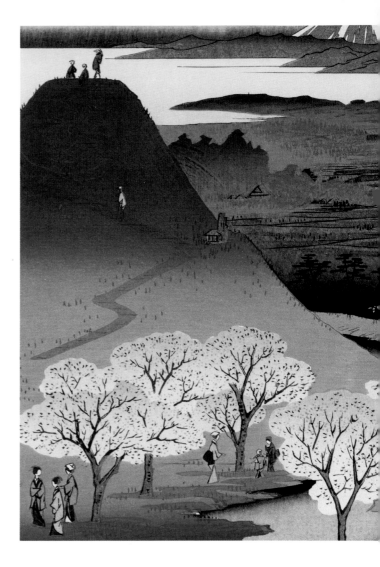

and spent their wealth on hedonistic indulgences. Urbanization was profligate: for example, Edo increased its population from the residents of a small village to more than a million inhabitants by the mid-eighteenth century, making it the most heavily populated city in the world at that time.

Hedonism in the Edo Period

The lower-class merchants were wealthy members of society, but were unable to utilize that wealth to increase their hierarchical status in Japanese society, choosing instead to spend their money on

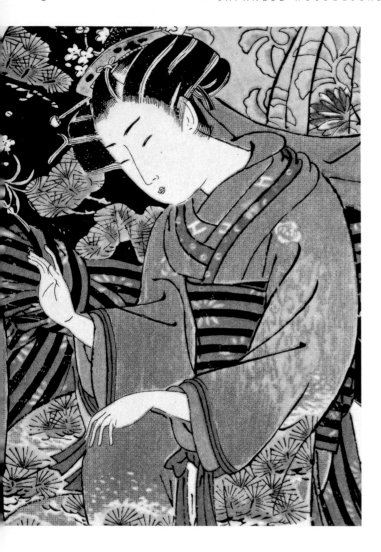

or female entertainer. Many of these geisha were accomplished dancers, musicians and singers, but often they provided companionship by reading stories and gossiping. Needless to say, Yoshiwara also became the city's red light district, with prostitution being banned outside the area. Depictions of prostitutes appeared as so-called *yuma* (bath girls) or courtesans in *ukiyo-e*, the former semi-clad or nude, with the latter as a woman who is educated and trained to pleasure men in a variety of ways other than sex (*see* page 31). The depiction of *yuma* was meant as a form of titillation to the viewer, whereas the posing courtesan was intended to stimulate many other earthly pleasures in the world of the *ukiyo*. At the beginning of the Edo period, the subtleties of the courtesan were known only to the samurai class, whereas by the nineteenth century, the middle-class bourgeoisie were also familiar with the protocols of the demimonde. The courtesans could be bought for a man's exclusive pleasure, and the demimonde became the social centre of male life, the destination of connoisseurs and literati, as well as the wealthier but less educated men with time and money to spare.

The Artisan Class

At the same time, the shogun was keen to promote literacy in his society as part of Confucian ideals on knowledge. At the beginning of the new regime, the shogun had introduced a huge movable-type system of some 100,000 pieces. Because of the complexity of the system in Japanese, artisans charged with creating books decided that woodblocks were quicker in producing the finished product, and by the middle of the seventeenth century, woodblocks had become the norm.

The effect of the rise in literacy created a huge demand for books during and after the seventeenth century, which was met by the artisan printmakers. Artists who were employed to illustrate these books also produced work in the form of woodblock prints that became fashionably collectable. This was the beginning of mass production of books in Japan as the population of literate citizens increased. The range of books also increased, from classic novels to travel guides, and from cultural guides to play scripts for use in the theatre, which had also become popular.

hedonistic indulgences within the *ukiyo* or 'floating world' of fashion, entertainment, erotica and the purchase of objects that had a perceived aesthetic quality. Typically, the images produced of this lifestyle, the *ukiyo-e*, were of beautiful and fashionable women, theatre performers and erotica. Such indulgences were not frowned upon, since Buddhism was not as critical of pornography and sex as was the Christian world.

The area of Edo called (New) Yoshiwara typified the 'floating world' and became the destination of the bourgeoisie for their indulgence of pleasure and luxury. The residents of Yoshiwara were mainly women who entertained their male clientele, offering the services of a geisha

Although this book is primarily concerned with the design and
publication of prints for decorative purposes, most *ukiyo-e* artists began
their apprenticeships and early careers designing plates for books.

Woodblock Printing

Woodblock printing in Japan, known as *moku hanga*, is most
effectively demonstrated in the *ukiyo-e* prints of the Edo period.
Although used in China for many centuries, the use of woodblock
printing was rare in Japan, being used only for the production of texts
and images in Buddhist temples.

The technique involves the creation of an image by the artist on to a
sheet of paper that is then glued face down on to a piece of flat wood,
usually cherry wood, which is then cut away according to the drawing's
outlines. The surface of the wood is then inked and a sheet of paper is
applied to it before using a baren tool to burnish the back of the paper,
transferring the image to the paper. Initially, and up until the mid-
eighteenth century, images were monochromatic, until Harunobu
produced his first polychromatic print around 1765.

The production of the print was separated into three stages: the
original design by the artist, the carving of the wooden block by an
engraver, and the inking and burnishing by a printer. With the early
woodblock prints in monochrome, the image was sometimes
subsequently coloured by hand, depending on the desired effect.
Unlike its European counterpart, the Japanese woodblock print was
very much a team effort in its production. All three of the people
involved were artisans and, during the Edo period, the designer was
no more important than the other two. In fact, both books and prints
were seen as utilitarian objects rather than works of art at the time of
their production; the prints had a transitory function as decorative
pieces, rather like posters today. Most purchased prints were literally
pasted on to walls to decorate homes, and had a limited shelf life.
Some, however, particularly at the luxury end of the market, were
kept in portfolios by avid collectors. The size of the prints varied from
the smallest *chûban* (26 x 19 cm / 10⅛ x 7½ in) to the largest
kakemono-e (76 x 23 cm / 30 x 9 in), the latter well-suited to the
narrow niches found in many Japanese homes of the time.

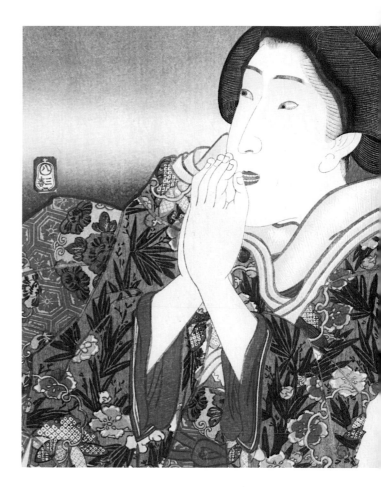

Early Edo Prints

Although the woodblock print was centuries old as an idea in China
and Korea, in one way at least it was perfected in Japan by the use
of handmade papers, which were the finest in the world and lent
themselves perfectly to the technique. Merchants recognized the
extraordinary qualities of the prints as evoking the hedonistic world of
ukiyo they themselves occupied, and began setting up publishing
houses as speculative ventures. The earliest *ukiyo-e* prints date from
about 1660, and were mainly erotica, illustrations for sex manuals
to train courtesans with uncoloured fine-line drawings that were
sometimes very explicit. These *shunga* works are often attributed to
the so-called Kanbun Master (fl. *c.* 1660–73), an anonymous artist
who acted as a mentor to the first of the recognized masters of *ukiyo-e*,
Hishikawa Moronobu (?1618–94).

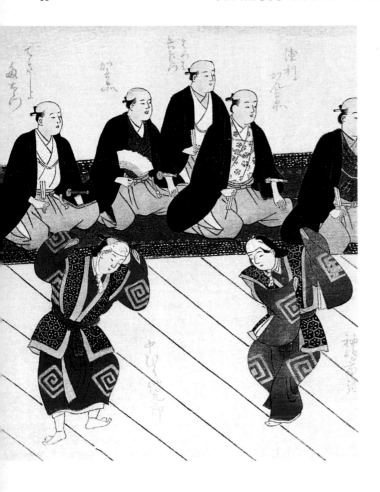

Hishikawa Moronobu

Sometimes seen as the 'founder' of *ukiyo-e*, Moronobu was the son of a famous artisan, a well-respected embroiderer of rich fabrics, a skill passed on to his son, who made his way to Edo in the late 1660s to study traditional styles of painting known as *tosa*. He began, like most *ukiyo-e* artists, working on book illustrations and quickly rose to fame as a master of the craft, a position he held until his death in 1694. His early book illustrations included *shunga* images that are clearly indebted to his Kanbun mentor, but by the 1680s, he had developed his own very distinctive style in which a strong black line dominated the design, making the figure more dynamic. In these images, he created a style that epitomized the beauty in the male and female forms in a way that had not been achieved by his predecessors. It is this aspect of the work that marks him out as the first *ukiyo-e* master (*see* page 82).

The Moronobu School

However, Moronobu's skills as a fine draughtsman were not limited to *shunga* images, which only accounted for about a quarter of his output. He also depicted aspects of seventeenth-century Edo society, as diverse as artisans at work, street markets and leisure districts. These portfolios of prints were usually arranged in groups of twelve images. The more explicit *shunga* images were often prefaced or interspersed with more romantic or courting scenes.

Moronobu was also the first *ukiyo-e* artist to establish a studio, where he could teach his skills to the next generation. His most notable pupil was his son Morofusa, who ultimately returned to the artisan skill of embroidery. His other eminent student was Sugimura Jihei, by far the most prolific of his followers. When Moronobu was at the height of his powers, a young artist called Torii Kiyonobu (1664–1729) arrived in Edo with his father Kiyomoto, an actor and painter. He developed the fine, bold lines of Moronobu's style and adapted it to suit depictions of the kabuki theatre.

Kabuki Theatre

At the beginning of the Edo period, a new type of dance-drama emerged in Kyoto. The style was dominated by Izumo no O-Kuni (dates unknown). Her all-female troupe played both male and female roles in small comic playlets, enjoyed by the Imperial Court. O-Kuni is therefore generally credited as the founder of this type of entertainment that came to be known as kabuki. The format was soon adopted by courtesans who 'entertained' their clientele with a mix of song and dance, and it would have been usual for her to engage in conversation about the cultural merits of the piece afterwards. Clients who tried to sidestep this protocol and force themselves upon the courtesan sexually were often referred to as *yabo* (vulgar boor), and were ridiculed in the social world of the demimonde.

The appeal of these often-bawdy plays grew, and several different troupes emerged, although by the middle of the seventeenth century, the shogunate had suppressed their activities due to their erotic nature. At this time, the boundaries between entertainment and

prostitution by the women of the troupes had become blurred. This led to a transition to all-male troupes, in which men played both male and female roles on the stages of regulated theatres. The subject matter was usually historical in nature, but could also depict everyday life and even satire, providing it was not critical of the shogunate. The audience already knew the play's narrative, so what they wanted to see were the elaborate and colourful sets and their favourite actor's interpretation of the dialogue. Part of the ritual was the heavy use of make-up by the actors, and their extravagant use of an ornate costume for effect, as seen in Kunisada's print (*see* page 96).

The opening of a new season of theatre was an opportunity for *kaomise* (face-showing), in which the newly employed actors were introduced to the audience. The season began in the winter around the New Year and ran until the following summer, when many of the established actors took a holiday, paving the way for new actors to perform in their place and giving audiences an opportunity to see fresh talent. Unlike Western theatre, the structure of kabuki is centred around dramatic moments of high tension in which the actors hold a rigid pose with their eyes crossed. These dramatic poses are known as *mie* and perfectly suited their portrayal by artists (*see* page 85).

Torii School

Torii Kiyonobu focused his talent on producing billboards for the theatre, and by 1700 was well known and established as an artisan. He was first and foremost a painter, but, like many contemporary artists, adapted his skills to the production of illustrations for books and prints. He is mostly remembered as the founder of the Torii school, the creation of a stylistic type rather than an establishment for educating followers of the style. He became known as Kiyonobu I to distinguish himself from some of his followers. Typically, these followers would adopt the name of the master, Torii, in recognition of his style. However some, such as Torii Kiyonaga (1752–1815) adapted the style, for example in his *Night Scene in Shinagawa* (*see* page 35), which is a departure from the dynamism of the theatre images per se, as it is softer and more elegant than earlier Torii school works.

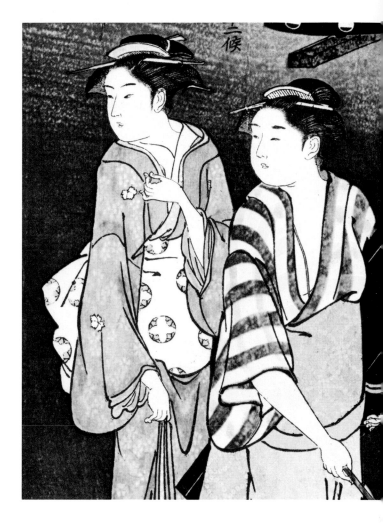

The style of the Torii school became an aspiration for all Japanese artists in the eighteenth century, because it typified *ukiyo-e*. The developing style embraced drama, using thick, bold lines that attracted the viewer, the original aim of a theatre poster. By the time of Kiyonaga, the images were being printed in full colour, without losing the sense of drama typified by the Torii school, but while also seeking more realism in depiction. Kiyonaga is generally regarded as the last of the Torii school.

Torii Kiyomasu

Although we do not know his birth or death date, we know that Torii Kiyomasu was active as an artist of the Torii school between 1695 and 1720. It is said that Kiyomasu was related to Kiyonobu I, and one can

see the similarity in the style of his kabuki billboards. With many of the Torii artists, it is very difficult to tell one from another, as the works are often unsigned and the styles are quite similar, but one can see differences in its development over the 100 years or so of its influence. Generally, the images by Kiyomasu are much softer and more feminine than those by Kiyonobu I, and certainly so when compared to Moronobu, whose work tended to be very masculine. Kiyomasu and other artists of his generation also adopted experimental techniques in their work, such as the use of lacquer to embolden the lines and adding metal dust to create lustre.

On page 83, we can see a typical image created by Kiyomasu of an actor, Nakamura Senya, portrayed as a female character turning to look at a cherry tree. The dynamism of the movement is fully captured in this image and is typical of the Torii school style.

Development of Lacquered and Coloured Prints

One of the most influential artisans of the *ukiyo-e* in the early years of the eighteenth century was Okumura Masanobu (?1686–1764). Although not recognized as a follower of the Torii school, or any school for that matter, Masanobu found fame as an illustrator of large-sized portraits of courtesans, using a bold style. However, unlike earlier artists, his images were less reliant on the kabuki dramas, as he sought other sources for influence such as flora and fauna. Due to government austerity measures during the *Kyōhō* reforms from 1717, Masanobu moved away from large work to small-scale albums of prints known as *urushi-e,* in which metal powder was sprinkled on the ink to create a lacquer effect. In 1721, he also opened his own publishing business.

By 1740, Masanobu had returned once again to the larger format, by producing *kakemono-e*-sized lacquer prints. At this time, he was also experimenting with the first real colour prints (*see* page 28). Until now, prints had been produced in monochrome and then hand-coloured. That is not to say colour printing had not been invented, but it was ill-suited to mass production due to economies of scale. As a publisher, it was Masanobu who developed a technique for colour registration, enabling mass production of two and three colours, usually green and

rose, both made from vegetable dyes. This paved the way for full-colour prints in the next stage of *ukiyo-e*.

Suzuki Harunobu

Very little of the early life of Suzuki Harunobu (?1725–70) is known, but he was a major figure in the development of *ukiyo-e*. Although he was certainly influenced by the former Edo masters, it seems that he may well have been a student of the Kyoto master Sukenobu. Harunobu was an innovator and took *ukiyo-e* to a new level by developing the full-colour print. What facilitated this was the artist's connections with the literati samurai class, who, almost on a whim, decided to use contemporary illustration in calendars and greetings cards as gifts for the New Year. Harunobu led the way in this, producing very fine multicoloured calendar prints from 1765 that

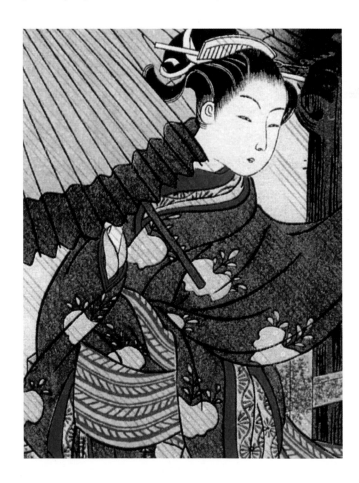

became known as *e-goyomi*, and were an instant success. Since the samurai class commissioned them, no expense was spared in this endeavour. Harunobu replaced the catalpa wood used in making the printing blocks with cherry wood, a much finer material; ordinary paper was replaced with a high-quality one; and the inks were superseded by a thicker, more opaque variety. This combination made colour registration easier and Harunobu was able to produce what became known as 'brocade' prints or *nishiki-e*, using separate woodblocks for each colour.

In the last five years of his life, Harunobu devoted all his time and energies to developing the 'brocade' print, producing in excess of one thousand prints. It was not just the colours that were so innovative, but also his choice of subject matter. He immortalized the ordinary everyday life in Edo, introducing a sense of realism rather than the hedonism of the pleasure world. His most remarkable achievement is probably the *bijin-ga* (pictures of beautiful women) he produced during this time. These delicate images were rarely surpassed in grace or elegance in subsequent generations (*see* page 30).

Isoda Koryusai

Trained directly by Harunobu, Isoda Koryusai (1735–90) was less of an innovator than his master and is often seen more as an emulator of his style, which he matched in terms of draughtsmanship. Koryusai was more inclined towards the realism of the Edo culture, a key feature in the last quarter of eighteenth-century *ukiyo-e*. He developed the pillar print (*hashira-e*) intended for use on the narrow supporting pillars of a Japanese home. He is also credited with producing prints in a new subject matter, *kachō-e* (flower and bird pictures, *see* page 106). Whilst Koryusai is well known for his *shunga* depictions, which in full colour added a new dimension to their eroticism, his most famous works are likely his courtesan portrayals (*see* page 31). His are more sombre in mood than those of his contemporaries, such as Ippitsusai Bunchō (active 1755–90), who was best known for his portrayals of kabuki actors, typically in Noh masked plays. Bunchō collaborated on a number of prints with both Harunobu and Koryusai, and significantly Katsukawa Shunshō (1726–93), paving the way for a new style of painting that became known as the Katsukawa school.

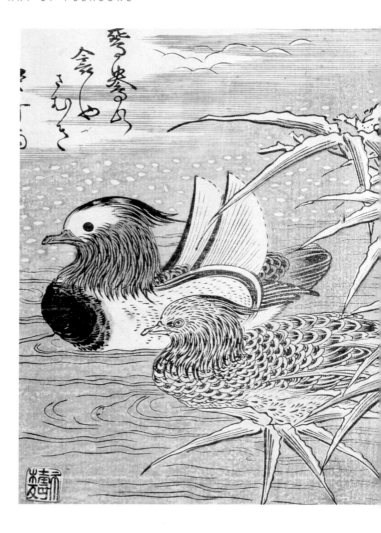

Katsukawa Shunshō

Although Katsukawa Shunshō can be considered to have been a member of the Torii school in his early career, he quickly developed a style that became uniquely his. His depictions of *bijin-ga* (pictures of beautiful women, *see* page 39) are clearly indebted to Harunobu, but his depictions of kabuki actors are more realistic than idealized, to the point where it is easy to distinguish one portrayal from another. Previously, the emphasis had been on the portrayal of the kabuki character, but Shunshō now depicted the actor in his own right, and theatre-goers were able for the first time to distinguish their favourite actor by his idiosyncratic features, as demonstrated in his triptych of actors (*see* page 86).

Like his contemporaries, in the second half of the eighteenth century Shunshō benefited from the resurgence of kabuki, as first exploited by Harunobu. However, it was Shunshō who was more adventurous with colour, emphasized by his strong use of black (*see* page 84).

Katsukawa School

There is little doubt that Shunshō developed a more realistic style that set the tone for Japanese woodblock printing into the nineteenth century. The Katsukawa school that flourished between 1765 and the early years of the nineteenth century adopted the ideas of artists from Harunobu through to Shunshō. It was actually founded by Miyagawa Shunsui (flourished 1740s–60s), who was Shunshō's tutor, and

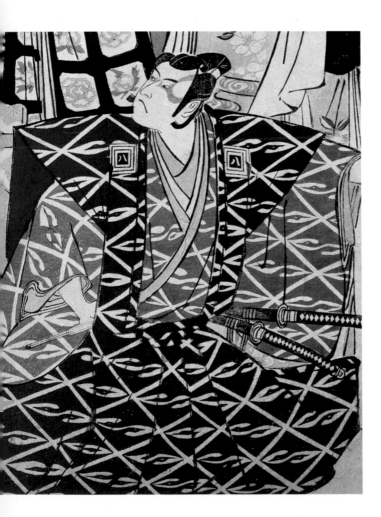

continued the tradition of realistic portrayals of kabuki actors. One of the most notable followers of the Katsukawa tradition in his early career was Katsushika Hokusai (1760–1849).

Not all artists at this time followed the Katsukawa school. One artist who bucked the trend and continued to embrace the Torii tradition was Torii Kiyonaga (1752–1815). His adoptive father and tutor was Torii Kiyomitsu (1735–85) and on his death, Kiyonaga was the most naturally talented of his pupils to succeed him as leader of the Torii school. Broadly speaking, his works depicted *bijin-ga* (although his women seem more mature than those of his contemporaries) and kabuki actors (*see* page 85).

Sharaku and Eishi

An artist of the late eighteenth century who does not fit in to any particular school is Tōshûsai Sharaku (active 1794–95), about whom we know almost nothing outside the work he executed. However, what marks him out as an *ukiyo-e* master is his realistic portrayal of kabuki actors that did not find favour with them or the general public, due to their unflattering imagery. His image of the actor Bando Mitsugoro is a prime example of his *oeuvre* (*see* page 87). He fell into obscurity and even today we do not know his true identity, although there is some speculation that it was the pseudonym of the master Hokusai.

Hosoda (a.k.a. Chobunsai) Eishi (1756–1829) is another artist who is difficult to categorize, as he came from the samurai class and was a student at the conventional Kano school, under the direction of the shogunate. In fact, it was Shogun Ieharu who gave him his artistic name when he became an official court painter. Sometime in the mid-1780s, he switched to *ukiyo-e* images and although one can see the influence of, for example, Torii Kiyonaga, Eishi's female figures are altogether more slender (*see* page 32). It is also possible to see the influence of his contemporary, Kitagawa Utamaro (1753–1806).

Kitawaga Utamaro

Utamaro's career began in earnest as a child under the tutelage of Toriyama Sekien (1712–68), an illustrator of folklore image, and by

the mid-1780s, he was living with the leading publisher of the day, Tsutaya Juzaburo (1750–97). Kitawaga Utamaro (1753–1806) worked for the Tsutaya firm as its principal artist until 1793, when he began producing his own *bijin-ga* work, observing women in the Yoshiwara district (*see* page 34). His depictions of women are far more sensuous than his predecessor's. He was clearly influenced by the graceful lines of Kiyonaga's *bijin-ga*, but he added a high degree of implied eroticism to his women. An example of this can be seen on page 36. His style became known as *bijin okubi-e,* and it differed from *bijin-ga,* as he depicted close-up images of beautiful women, a style normally reserved for portraits of kabuki actors. Utamaro's beautiful women were portrayed with individual character, often nuanced, in contrast to other artists, who used a more idealized style of portrayal.

Kensai Reforms and the Decline of the *Ukiyo-e*

During the 1790s, a series of so-called sumptuary edicts were issued that were designed to curtail the excesses of the liberal book and print trade. They came to be known as the Kensai Reforms and were designed to suppress the 'expression of ideas', lest they became subversive. Although not written into law, publishers were advised to adhere to the spirit of the edicts or face financial penalties. When Juzaburo published prints by Utamaro that violated censorship laws, the former had half of his net worth confiscated by the authorities and the latter ended up in prison, where he died in 1806.

These reforms had an adverse effect on the popularity of the *ukiyo-e* prints at the end of the eighteenth century, and artists began to focus on harmony and beauty in their depictions rather than the demimonde. An example can be seen in Utamaro's depiction of a middle-class mother and daughter (*see* page 38).

Utagawa Toyokuni

Although not the founder of the Utagawa school, Utagawa Toyokuni (1769–1825) was its most important master, having adopted the *gō* (artistic name) from his tutor Utagawa Toyoharu (1735–1814), who, like Utamaro, had studied under Sekien. Toyoharu was among the first

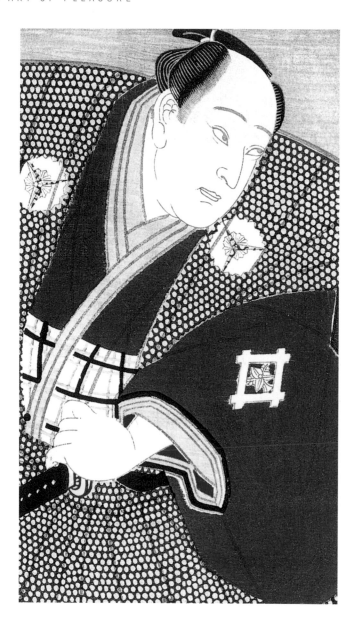

Japanese artists to study perspective in Western art. Toyokuni adopted a very eclectic style, having emulated many of his contemporary *ukiyo-e* artists. For example, his *Woman with a Calligraphy Brush* demonstrates a similar sensibility to the *bijin-ga* work of Utamaro (*see* page 41), while his triptych of *Girls Washing* is clearly indebted to the work of Torii Kiyonaga (*see* page 44–45). By far his best works were the portrayals of kabuki actors, for which he became well known, and are among the finest of the genre (*see* page 88).

The Utagawa School

In part because of the Kensai Reforms, but also due to the lack of further innovation, the portrayal of figures in *ukiyo-e* was in decline at the end of the eighteenth century. There were, however, a number of followers of Toyokuni who continued producing *bijin-ga*, as well as portraits of kabuki actors into the nineteenth century. They belonged to the Utagawa school. Traditionally, the most senior artist in the school became the new Toyokuni on the death of the master, and in 1826, a year after his master's death, Toyoshige (1777–1835) assumed the title of Utagawa Toyokuni II, since he was a pupil and adopted son of the master. His claim was challenged, however, by other followers – most notably Utagawa Kunisada (1786–1865), who became Toyokuni III in 1842 – due to the mediocrity of his work.

The Landscape

It was Utagawa Toyoharu, the founder of the school, who, having studied the use of perspective in Western art, introduced the idea of landscape painting as a subject matter in itself to *ukiyo-e*. Up until this time, landscapes were used merely as a background to a subject, with little or no regard given to perspective or scale. Clearly, one can see the introduction and influence of Western perspective in Toyoharu's series *Perspective Views of Famous Places of Japan* (*see* page 56). It was, however, the Katsukawa school protégé Katsushika Hokusai who was to become the early master of the landscape genre.

Katsushika Hokusai – Early Years

This early master of the landscape genre was adopted into an artisan family, with Hokusai's father, Nakajima, being the mirror-maker for the shogun. Katsushika Hokusai (1760–1849) was never made an heir, which suggests his mother was a concubine. He began to show a talent for painting as early as five years of age and, at the age of 14, was apprenticed to a woodcarver, where he learned the craft of woodblock carving that was to serve him well in his future as a printmaker. At the age of 18, he was accepted into the Katsukawa school under the tutelage of its master Shunshō. A year later, Hokusai was named Shunrō by his master, in recognition of the talent of his

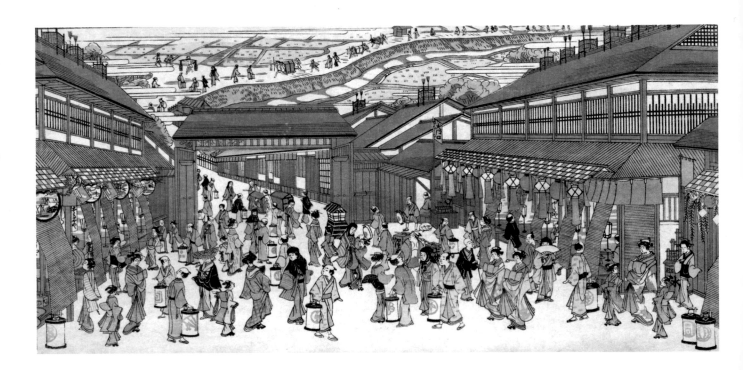

protégé, one of many names that he was to adopt in his early years as an artist. It was under the name of Shunrō that he produced his first published work, a series of paintings of kabuki actors.

Following the death of his master in 1793, Hokusai was expelled from the school by Katsukawa Shunkō (1743–1812), who became its new head, an inspirational moment for the protégé, who saw this embarrassment as an epiphany in the development of his work. Recognizing the limited potential of figurative work, Hokusai turned his attention to landscapes. In 1798, he changed his name to Hokusai Tomisa, and by 1800, was more widely known as Katsushika Hokusai, after the area of Edo in which he was born. In the first decade of the nineteenth century, he designed many landscape pictures, beginning with the series 'Eight Views of Edo' and 'Landscapes in the Western Style', influenced almost certainly by the limited access he had to prints of Dutch landscapes. These were followed by the series 'Fifty-three Stations of the Tōkaidō' (which actually consisted of 59 prints). The 'stations' were a series of stopping and resting points for travellers making the journey from Edo to Kyoto along the coastal road then known as the Tōkaidō Highway, which inspired both Hokusai and later Hiroshige. The print shown on pages 58–59 is the view from Okazaki. This hilly, forested area is situated in the coastal plains of today's Aichi prefecture, and was one of the 53 stations.

Hokusai was not, however, limited to landscapes at this time. His output was eclectic and ranged from painting a giant portrait of the Buddhist priest Daruma, using a broom (now destroyed), to collaboration with the popular novelist Takizawa Bakin (1767–1848) on a series of illustrated books. He also produced *shunga* illustrations for erotic books, as well as flora and fauna images (*see* page 109). Of all the *ukiyo-e* artists, Hokusai was not only the most eclectic of artists, but he was also a first-rate self-publicist. One, now legendary, story has Hokusai at the court of the shogun, where he was asked to demonstrate his skills. He painted a blue curve on a large sheet of paper and then got a chicken whose feet had been dipped in red ink to run across it, explaining to the shogun that his image represented a river with maple leaves falling on to it. The shogun was suitably impressed with his genius.

Katsushika Hokusai – Mature Years

In 1811, Hokusai was over 50 years old and changed his name again, this time to Taito. He began a series of *manga*, or art manuals, designed to educate his pupils and as a way for him to make money quickly, as he was no longer eligible for the stipend he had hitherto enjoyed. Between 1812 and 1820, he had published 12 volumes of these *manga* and had in excess of 50 pupils, including his two daughters, none of whom were able to equal the talents of their master. He also published his most evocative *shunga* manuals at this time.

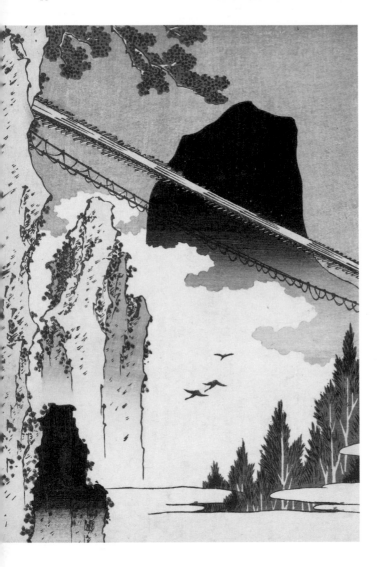

In his long career, Hokusai was the most prodigiously active *ukiyo-e* artist of all time, although much of his life was spent in poverty. He changed his name at least 20 times and moved home on nearly 100 occasions. In all, he produced over 30,000 images, although, as one would expect, not all of the same high quality that he is renowned for. In 1839, ten years before his death, Hokusai's studio caught fire and destroyed most of his work, a loss that may have contributed to the fall in the quality of his work in his last decade. His influence was, however, important to other artists in Japan at a time when the number of depictions of the demimonde was waning; it was Hokusai who sought out new subjects to maintain the importance and stature of *ukiyo-e*.

Other Artists

Despite the move away from figurative images, there were still several artists in Edo who portrayed the actors and beautiful women of the era. An artist who was influenced by both Utamaro and Hokusai, but who was never their equal, was Kikugawa Eizan (1787–1867), with his *Geisha Reading a Book* being a good example of his *bijin-ga* (*see* page 40). He was not, however, a pupil of Utamaro or Hokusai, but of the latter's pupil Totoya Hokkei (1780–1850). Eizan's work is at best well executed, but it lacks the sensitivity of his contemporary Utagawa Kunisada (1786–1865). Another contemporary was Torii Kiyomine (1787–1868), who was tutored by Torii Kiyonaga and later adopted the name of Torii Kyomitsu II, specializing in *bijin-ga* images (*see* page 42), by which time the Torii school was in decline as an influence.

The most notable period in Hokusai's artistic life was, however, the latter part of his career, beginning in 1830 when he was 70 years old and working under the name of Gakyō Rōjin Manji, which literally means 'old man crazy about art'. He began the series of landscapes he is most famous for, 'Thirty-six Views of Mount Fuji' (*see* page 57), which includes possibly his best-known image, *The Great Wave off Kanagawa* (*see* page 61). This was followed by the series *Wondrous Views of Famous Bridges in All the Provinces*, a collection of 12 prints (although only 11 are known, *see* page 67), and *A Journey to the Waterfalls of All the Provinces*, which probably comprised 12 images although, again, only 11 are known (*see* page 66).

Keisai Eisen (1790–1848) was from a samurai class family and studied under Eizan. Like many of his predecessors, he illustrated erotic books known as *shunga*, where he used the name Insai Hakusui. His *bijin-ga* images are among the best known, although his subjects are treated, rather like his master Eizan, with less sensitivity and sensuousness than they are in the work of his contemporaries. His images do, however, give one a sense of the everyday fashion of the time, the 1830s (*see* page 47). Eisen was also a painter of landscapes, his most memorable being the 'Sixty-nine Stations of the Kiso Highway' series, which he began, but which was completed by Hiroshige (*see* page 69).

Utagawa Kunisada

Utagawa Kunisada (1786–1865), also known as Utagawa Toyokuni III, was arguably the most popular and financially successful creator of *ukiyo-e* images in the nineteenth century. He was born in Honjo, a district of Edo, but we know little of his early life except that his father died when he was very young. At that time, he was known as Sumida Shōzō. His early sketches impressed the great master of *ukiyo-e*, Toyokuni, who accepted him into the Utagawa school at about the age of 14 as an apprentice, when he was given the name of Kunisada, after his tutor. He very quickly became his protégé, as his illustrations for books became extremely popular from about 1810, when he took the studio name of Gototei, a reference to his late father's business. The signature on *Mirrors: Getting Glamorous*, *c.* 1823, reads 'Gototei Kunisada' (*see* page 46).

By this time, Kunisada was counted among the elite of the *ukiyo-e* world, second only to Toyokuni. This is mainly because he developed his own style and, as a trendsetter rather than a follower, his images were always in demand. He was also extremely prolific, with some estimates of his output exceeding 20,000 designs for woodblock prints. Although he produced many *bijin-ga* images (*see* page 49), his main activity, like most members of the Utagawa school, was in depictions of actors (*yakusha-e*) in the kabuki theatre. In addition, he also produced a great many *ukiyo-e* images of sumo wrestlers, in which he dominated the market.

One of the most famous actors of the period was Ichikawa Danjuro VII (1791–1859), and he was frequently depicted by Kunisada in his various roles. Danjuro had a reputation for portraying the most flamboyant and daring characters on stage, an image that was well captured by Kunisada (*see* page 89). They were close contemporaries and became famous at about the same time, during the second decade of the nineteenth century. However, Danjuro, unlike Kunisada, was expelled from Edo for living a decadent life that was not in keeping with the shogunate authorities. While he was in exile for five years, his sumptuous house was demolished and his son committed suicide. Danjuro's expulsion was, in part at least, due to the Tenpō Reforms, which were further sumptuary edicts.

Between the years 1842 and 1850, these reforms ensured that 'luxurious' and decadent depictions of actors, courtesans and geisha should be forbidden, due to their detrimental influence on public morality. In their place, the government edict prescribed images based on loyalty and filial piety, in line with Confucian thought. The number of colours also had to be restricted to eight, in order to restrain their luxuriousness. Kunisada's 1841–43 portrait of Tamizo Onoe (*c.* 1799–1886) is an example of this restrained technique and composition (*see* page 93).

By 1850, most of these rules had been relaxed and one can see the difference in Kunisada's later, more exuberant images, such as the actor Arashi Rikan III (1812–63) portrayed as the hero Jiraiya (*see* page 97). Kunisada had already illustrated a series of books based on the story of the hero, and his print of the actor would have suited the authorities' prescription for the depiction of chivalrous heroes.

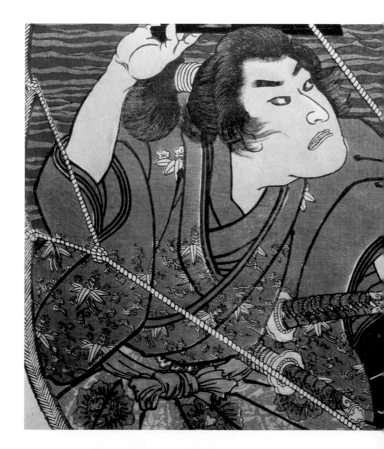

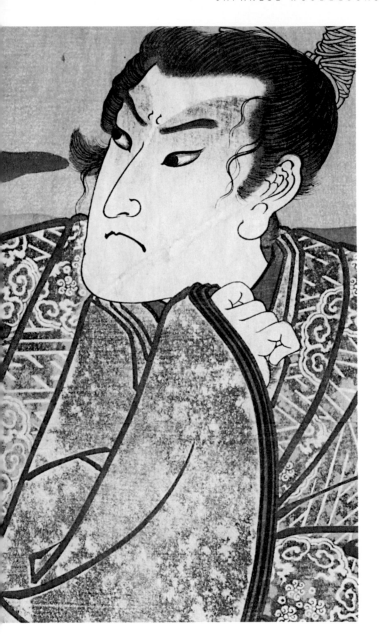

Utagawa Kuniyoshi

Another member of the Utagawa school was Utagawa Kuniyoshi (1797–1861), who, like Kunisada, was very prolific in his output, but he had a more diverse mix of subjects, most particularly legendary samurai heroes. He was also known for his depictions of animals, which were often used to satirize the shogunate by depicting them

in a caricatured manner. This was, of course, in response to the Tenpō Reforms of the 1840s. The fact that his images went unpunished demonstrated the weakening power of the shogunate, despite their attempts at reform. In the previous decade, Kuniyoshi had already flouted the censorship laws by producing a series of landscapes that encouraged travel. The style of these paintings was clearly influenced by Hokusai.

The fact that the artist also depicted kabuki actors as legendary samurai heroes may have further contributed to the leniency of the shogun government towards him, since these images would have suited their sensibility for loyalty and filial piety. Two of his best-known depictions are of Minamoto no Yoshitsune (c. 1159–89), who was a formidable military commander, as portrayed in the kabuki drama *Night Attack on Fort Horikawa* (*see* page 94), and another was Minamoto Tametomo (dates unknown), a twelfth-century warrior whose exploits were fictionalized by the writer Takizawa Bakin in his novel *Yumibari Tsuki*, which means 'Bow of the Full Moon' (*see* page 98).

Utagawa Hiroshige

Arguably the last great master of *ukiyo-e*, Utagawa (née Andō) Hiroshige (1797–1858) is best known for his evocative landscapes. He was born into the samurai class, although his father, Andō Genemon, was an adopted son. He was the fire warden at Edo Castle, a position he passed on to Hiroshige in 1809, when he was just 12 years old. In the same year, Hiroshige's mother died, and his father died the following year. It was not uncommon, however, at this time for a young man to inherit such responsibility. Notwithstanding this prestigious post, Hiroshige had a good deal of free time in which to develop his passion for drawing. In 1811, he joined the Utagawa school under the tutelage of Toyohiro (1773–1828). Despite his talent, Hiroshige was not a protégé and up until about 1830, he produced work that was not dissimilar to his peers: images of kabuki actors, *bijin-ga* and samurai warriors, which he signed Ichiyûsai. In 1823, he resigned his duties as fire warden, passing them on to his brother Tetsuzo, although he continued to live at the castle barracks as a deputy warden until

1840. In 1828, his master died and, unusually, Hiroshige declined the opportunity to be known as Toyohiro II. Instead, he began to forge a name for himself in landscape painting.

His early experiments in this genre emulated both Toyohiro and, more relevantly, Hokusai, for example, in his series 'Famous Places of the Eastern Capital' (*see* page 64), published in 1831, and repeated in different series such as 'Famous Teahouses in Edo' and 'Eight Views of the Sumida River', culminating in one of his most famous series, 'One Hundred Famous Views of Edo', which actually comprised 119 images published between 1856 and 1959 (*see* page 73). In 1832, he embarked on a trek along the Tōkaidō Highway, an ancient route that had become popular since the rise of Edo in the seventeenth century. The 300-mile trek was conveniently divided up into 53 resting places, which were used by Hiroshige to capture the essence and mood of each particular place.

Hiroshige's images are more striking in colour and atmosphere than Hokusai's version of the stations made 30 years earlier, his *Snow in the Precincts* of 1831 being a prime example (*see* page 62). This series assured his future and was reissued twice more, once in collaboration with Kunisada. His images resonated with the wanderlust of many Japanese people at this time, across all classes, who wanted to travel to other parts of the country, leading to a plethora of travel guides and novels on the subject. What Hiroshige managed to achieve in these landscapes was a unique blend of realism and romanticism, together with his use of unusual vantage points that set him apart from others such as Hokusai. In fact, it was the latter who was inspired to create more romantic images as a result of seeing Hiroshige's work. In the late 1830s, Hiroshige paid homage to Hokusai by designing his own version of the 'Sixty-nine Stations of the Kiso Highway' (*see* page 69), and then 'Thirty-six Views of Mount Fuji in 1858' (*see* page 76). One of his last landscape series was 'Famous Places: The Sixty-odd Provinces', published between 1853 and 1856 (*see* page 72).

At the time he was producing his first landscape series, Hiroshige was also drawn to the flora and fauna of his country as a motif. Again, the inspiration for this was Hokusai. Hiroshige produced two series of prints of fish in 1832 and 1840 (*see* page 114–17), several series of

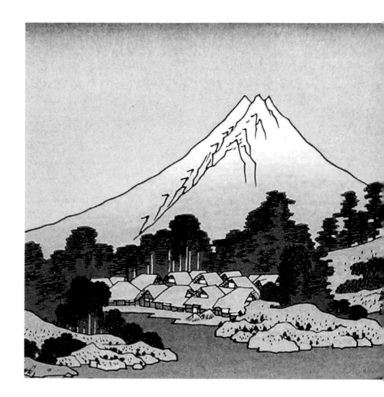

bird prints in different formats that usually included some flora (*see* page 113), and he also managed to include various animals in his landscapes (*see* page 124).

Hiroshige was a very prolific artist, creating well in excess of 5,000 images. Despite this, he lived a fairly frugal life and never enjoyed financial security even in his last years. He retired two years before his death and became a Buddhist monk, dying at the age of 62, probably from cholera. He had a number of students, including his future son-in-law Chinpei Suzuki (1829–69), who became Hiroshige II on the death of the master. Hiroshige II's marriage was dissolved in 1865 and his wife remarried, her new husband assuming the title Hiroshige III.

The Collapse of the Tokugawa Shogunate

Despite the final edicts of the Edo period, known as the Ansei Reforms, beginning in 1854, the demise of the Tokugawa shogunate was already well under way. Various factors had caused the decline in fortunes, exacerbated by a number of natural disasters including

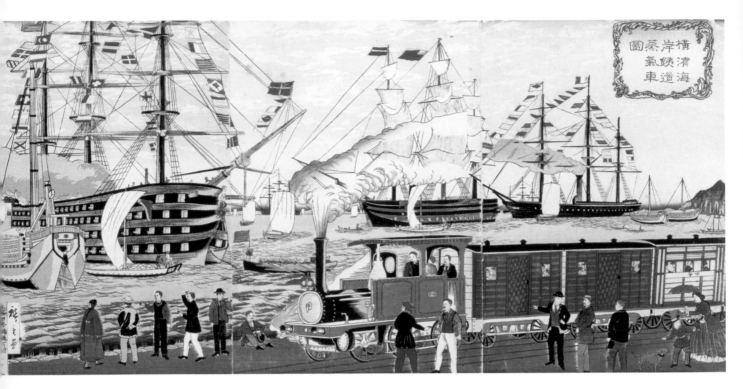

earthquakes and famine. The *bakufu* continued to resist calls to open its borders to trade with the West, most notably the USA, much to the chagrin of the merchants of Edo, who were now a more powerful class.

In July 1853, a squadron of four ships from the USA, commanded by Commodore Matthew Perry, arrived in Edo Bay. A standoff ensued and lasted until the following March, when the Treaty of Kanagawa was signed, allowing limited trade with the Americans (*see above, Commodore Perry's Gift of a Railway to the Japanese in 1854*, c. 1854 by Utagawa Hiroshige). Within five years, the *bakufu* was forced to increase this trade significantly, which led to an economic crisis in Japan, as the country was now importing goods that were far cheaper than those produced at home, and gold was substantially devalued. A further treaty with the USA allowed more of Japan's ports to be opened for trade, and residences were established for foreigners to exploit the commercial opportunities. Significantly, these foreigners were not subject to Japanese law under this treaty.

In 1858, another earthquake and a cholera epidemic (which possibly killed Hiroshige) added to the pressure being brought on

the *bakufu*, which was criticized for its relaxation of trade with the outside world. It responded with the so-called Ansei Purges, expelling from the *bakufu* and the Imperial Court those who did not support its policies of foreign trade. Various attempts were made by the *bakufu* to reassert itself militarily by building new warships and creating a more modern army, but in 1864, a combined fleet of British, Dutch and American warships bombarded the Japanese coast, forcing more of its ports to open.

In the short space of five months, beginning in September 1866, both the shogun and the Emperor died, which led to the Keiō Reforms, a series of measures to suppress dissatisfaction in certain provinces by adopting some Western ideas of government, including the removal of some class distinctions, a key feature of the feudal shogunate. Ultimately, this led to a civil conflict known as the Boshin War between the shogunate and the conservative Imperial Court, that lasted from January 1868 to May 1869, with victory for the Emperor. Ironically, at the end of the war, the 15-year-old Emperor Mutsuhito (1852–1912) continued to allow foreign trade with Japan, changing his name to Meiji, meaning 'enlightened rule'.

The Meiji Period

Following the fall of Edo and its renaming as Tokyo, which means 'eastern capital', Japan began a huge programme of modernization, becoming industrialized and adopting many aspects of Western politics and rule. In fact, it had ambitions, rather as Britain and France were already, of becoming a colonial power. One Japanese artist who was inspired by Western ideas of modernity was Kobayashi Kiyochika (1847–1915), who tried to assimilate aspects of the modern world, such as railways, into his images, which did not conform to the *ukiyo* genre. He had greater success with his more conventional and traditional images such as those of flora and fauna (*see* page 125).

Influences on Western Art

Just as Western art influences had crept into Japanese culture before the demise of the shogunate, Japanese woodblock prints were also known to European artists. The opening of the borders after 1853 increased the awareness of each other's cultures very rapidly, so that, by the beginning of the Meiji period, Japanese motifs were not only well known in Paris, for example, but eagerly copied, lampooned and pastiched. It was the Impressionists such as Claude Monet (1840–1926), and the Post-Impressionists such as Vincent van Gogh (1853–90) who most eagerly sought out the Japanese prints that could be purchased very cheaply in Paris. Another Impressionist, Camille Pissarro (1830–1903), remarked 'Hiroshige is a marvellous Impressionist', after seeing his work at an exhibition. The Anglo-American artist James McNeill Whistler (1834–1903) was also inspired by Japanese art. His paintings of the 1860s adopted a mode that came to be known as *japonisme,* in which Western models were dressed in kimonos as stereotypes, but it was his famous nocturnes, with their ethereal nature and unusual vantage points, that were clearly indebted to Hiroshige.

Japonisme and Art Nouveau

The influence of Japanese aesthetics in Europe began in Paris in the 1860s, following the lifting of Japan's trade embargo. It began with a craze for collecting all things Japanese, from ceramics to prints and books of the *ukiyo*, purchased at shops such as *La Porte Chinoise*. By

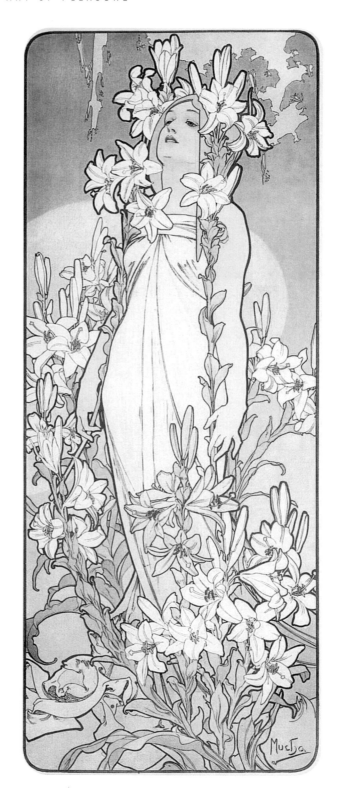

the 1870s, the craze had begun to influence artists, often in pastiche; Monet's portrait of his wife in a kimono from this time is a prime example. However, later artists such as Henri de Toulouse-Lautrec (1864–1901) began to adopt a distinctive style that was Japanese influenced, for example, in his theatrical poster designs in which he used flat areas of bold colour and a more simplified design clearly indebted to *ukiyo-e*. At the turn of the twentieth century, other artists also adopted similar ideas, such as Alphonse Mucha (1860–1939), whose Japanese-inspired work *The Flowers: Lily, 1898* can be seen on page 23.

The influence was not just in painting but in design as well, for Charles Rennie Mackintosh (1868–1928) and Christopher Dresser (1834–1904) in Britain, the Wiener Werkstätte in Vienna, and Frank Lloyd Wright (1867–1959) in the USA, among many others. Music too, was influenced by Japanese culture, for example, in Gilbert & Sullivan's *The Mikado*, written in 1885, and *Madama Butterfly*, written by Giacomo Puccini (1858–1928) and first performed in Italy in 1904.

The Japanese influence was also crucial to the development of the style known as Art Nouveau that flourished in Europe at the end of the nineteenth century, taking its lead from the 'whiplash' curvilinear forms, patterned surfaces and flatness of picture plane used in *ukiyo-e*.

The Twentieth Century

At the end of the Edo period, Hiroshige, Kuniyoshi and Kunisada were considered the finest creators of the Japanese colour woodblock print. However, among European and American collectors of Japanese prints, a fashionable pursuit in the late nineteenth and early twentieth centuries, all three artists were actually regarded as rather inferior to the greats of classical *ukiyo-e*, and even as having contributed to the demise of the genre, their work being categorized as 'decadent'.

A small number of artists continued to produce woodblock prints well into the twentieth century, using the *ukiyo-e* techniques already established, despite there being a diminished market for them. The

influx of Western art into Japan at this time could not easily be accommodated in the more conventional Japanese homes, due to its format. Consequently, the *ukiyo-e* images continued to be reproduced for both sentimental and practical purposes, albeit not to the same standard of creativity or originality as those produced by the masters. Yamamoto Shōun (1870–1965) is one such artist, who continued in the tradition of *bijin-ga* (*see* page 51).

Neo-ukiyo-e

The deterioration in the market for *ukiyo-e* was also in part due to the feeling that the mass production of these prints contributed to their lack of individuality and luxuriousness. In an attempt to resurrect the ancient forms and standards of woodblock printing using a traditional division of labour, a number of artisans worked at producing *ukiyo-e* images that became known as *shin-hanga* ('new prints') or neo-*ukiyo-e*. The patronage for these mainly comprised Western art dealers. Hashiguchi Goyō (1880–1921) was an artist who responded to this neo-*ukiyo-e*, producing very stylized images of Japanese women in a contemporary context that appealed to Western tastes, for example, the nude (*see* page 53).

The principal publisher behind the *shin-hanga* was Watanabe Shōzaburō (1885–1962), who employed highly skilled artisans to carve the woodblocks and print the images, commissioning artists such as Goyō to create the designs. Another artist to benefit from a collaboration with Shōzaburō was Natori Shunsen (1886–1960), who produced a whole series of images of kabuki actors in the *ōkubi-e,* or large head format, similar to Sharaku, that enables the viewer to examine the actor's expression (*see* page 103). Landscapes also continued to be popular, particularly when executed by Hasui Kawase (1883–1957), who was clearly indebted to Hiroshige in the evocation of the seasons (*see* page 79). Kawase was also one of Shōzaburō's stable of artists.

Epilogue

Despite these 'Johnny-come-lately' artists of the late nineteenth and early twentieth centuries, by the 1850s, the demise of the genre had

already occurred. One has to see the demise of the *ukiyo-e* print as synonymous with the demise of the *ukiyo* itself, a 'floating world' that existed in a society cut off from the rest of the world and only able to look inwards. As it progressed kicking and screaming towards an industrialized and modern future under the influence of the West, Japan had to look beyond its inwardness to a global future that no longer had any use for such a fantasy world.

Ironically, for twentieth century artists and modern viewers today, these prints portraying notions of a 'floating world' provided, and continue to provide, a means of escape from the burgeoning industrialization and minutiae of everyday life.

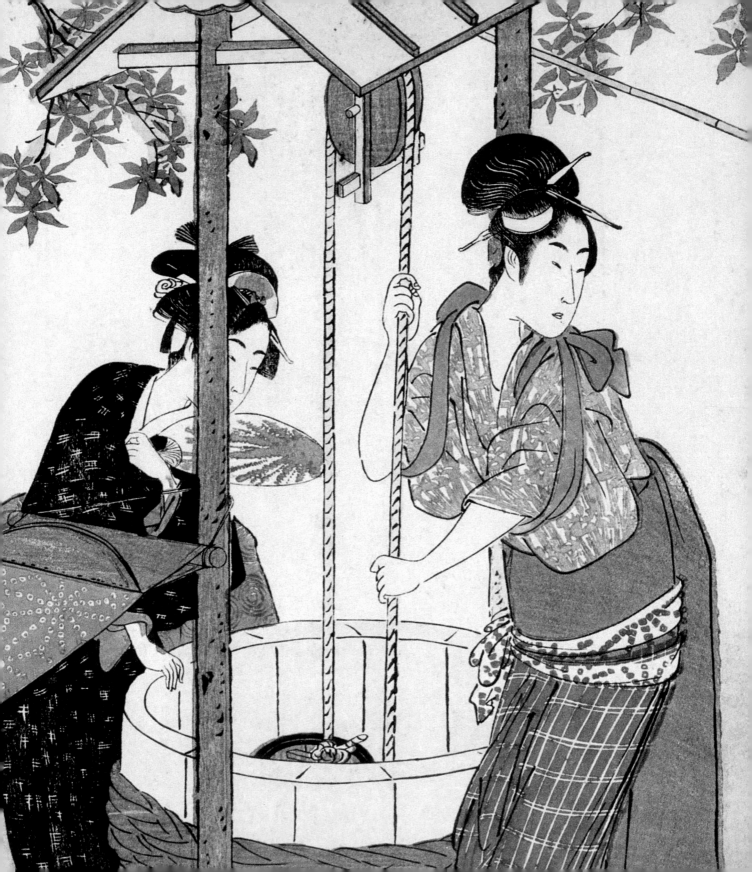

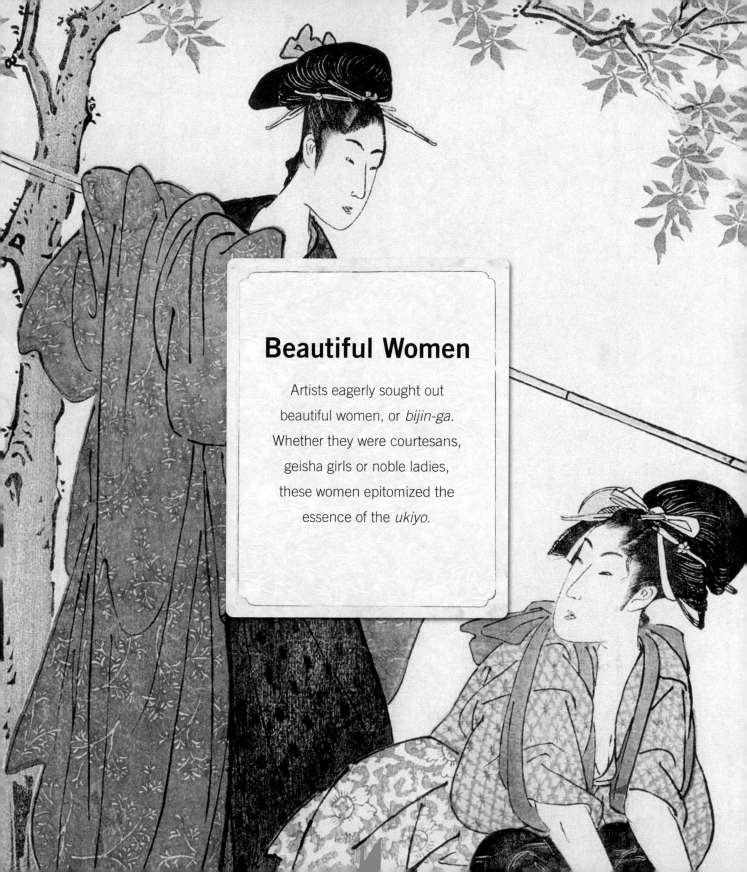

Beautiful Women

Artists eagerly sought out beautiful women, or *bijin-ga*. Whether they were courtesans, geisha girls or noble ladies, these women epitomized the essence of the *ukiyo*.

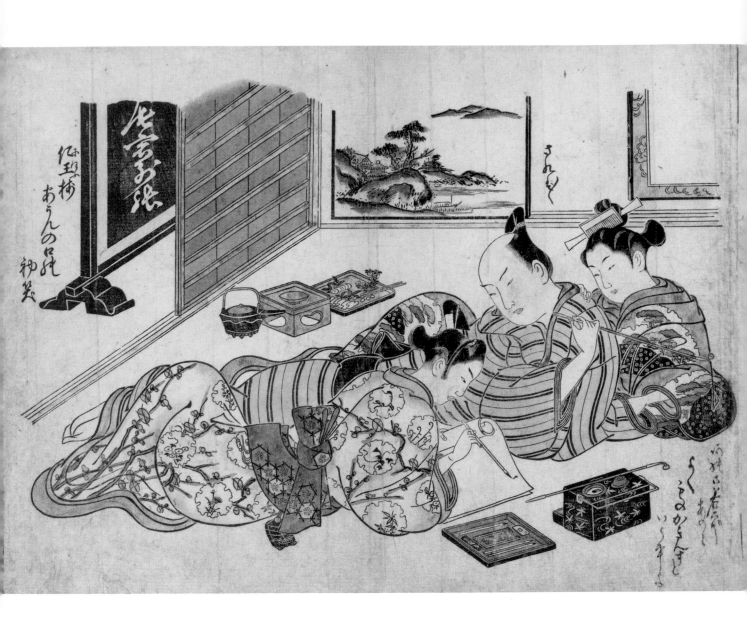

Print by Okumura Masanobu (?1686–1764)
Colour woodblock print, 27.3 x 38.8 cm (10¾ x 15¼ in)
• Brooklyn Museum, New York

Daytime in the Gay Quarter, *c.* **1739.** Masanobu was the first *ukiyo-e* artist to experiment with coloured prints made from separate plates. At this early stage, the colours were limited, as shown in this print.

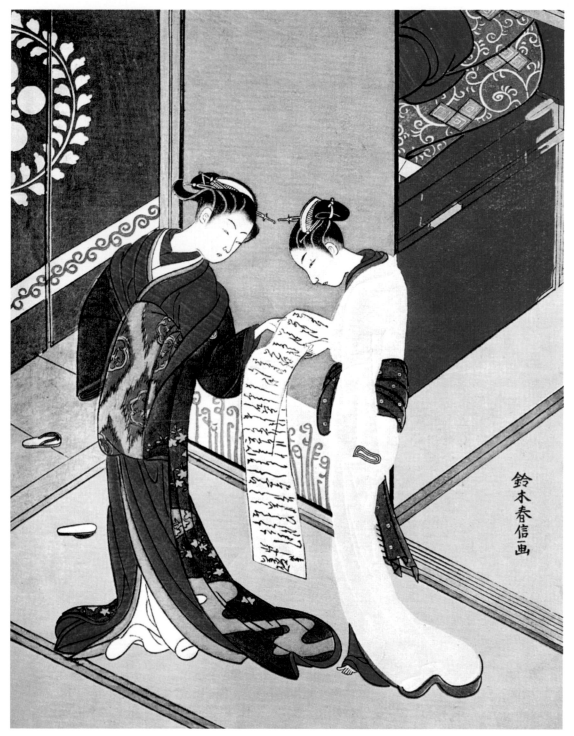

Print by Suzuki Harunobu (?1725–70)
Colour woodblock print • Private Collection

Two ladies, 1750. Harunobu was a great innovator and developed the first full-colour *ukiyo-e* print. Note the lush use of red and gold in this image, particularly in the kimono of the lady on the left.

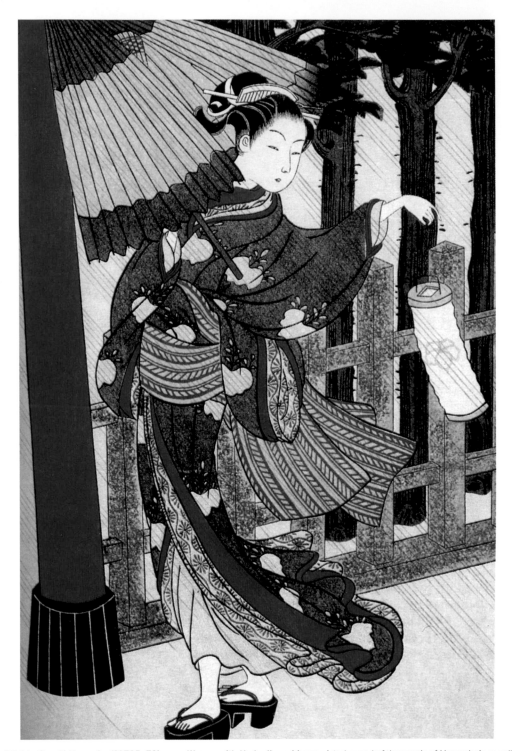

Print by Suzuki Harunobu (?1725–70)
Colour woodblock print

Woman with Umbrella and Lamp. A truly wonderful example of Haronobu's so-called 'brocade print', a technique that enhances the brilliant colours used in this everyday *bijin-ga* image of a windswept woman, her elegance and poise unruffled.

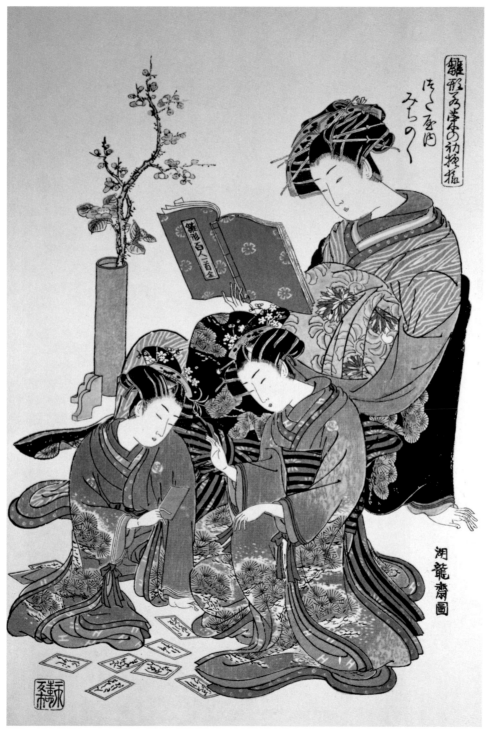

Print by Isoda Koryusai (1735–90)
Colour woodblock print
• Private Collection

Courtesan Michinoku Reading a Book, *c.* **1780.** The Courtesan Michinoku was well known in the *ukiyo*, and was depicted by several artists. Here, she demonstrates her rank in the higher echelons of society by reading, while her two attendants play cards.

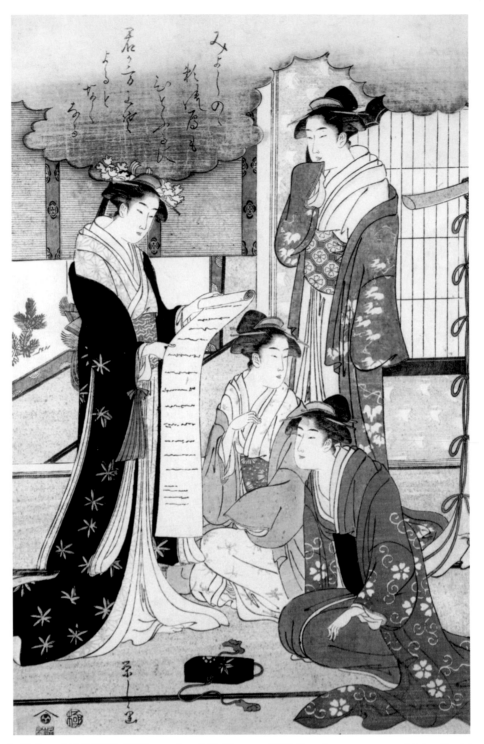

Print by Hosoda (Chobunsai) Eishi (1756–1829)
Colour woodblock print, 36.7 x 24.7 cm (14⅖ x 9⁷⁄₁₀ in)
• Professor Franz Winzinger Collection, Regensburg

Four Noble Women, *c.* 1792. These four women are possibly from the *daimyo* or noble families of the feudal lords who controlled large areas of land. Originally a court painter, Eishi would have been well acquainted with many of these noble women.

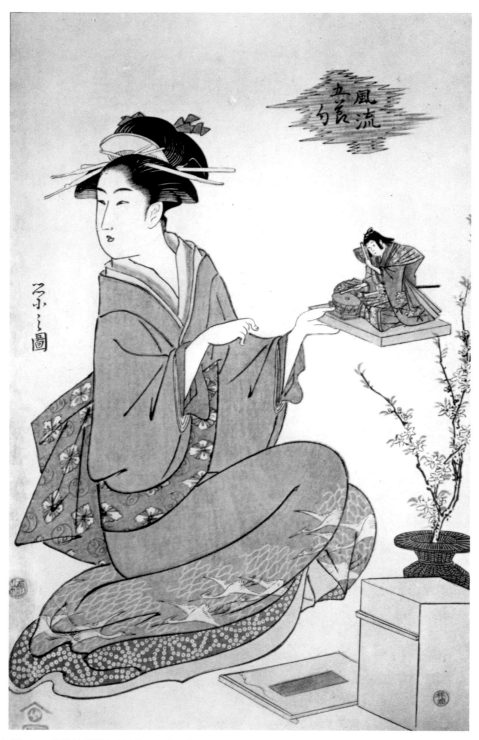

Print by Hosoda (Chobunsai) Eishi (1756–1829)
Colour woodblock print, 37.5 x 25.2 cm (14⅞ x 9⁹∕₁₀ in)
Colour woodblock print • Private Collection

The Puppet Festival, 1795. This image of a seated *bijin-ga* depicts a woman holding a puppet or doll, and is one of a series of prints by Eishi of the 'Fashionable Five Festivals', published in 1795.

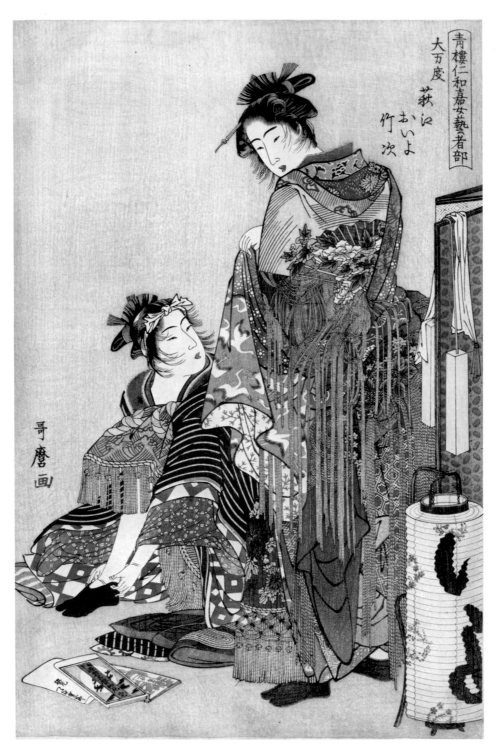

Print by Kitagawa Utamaro (1753–1806)
Colour woodblock print

Two Geisha Dressing for a Festival, 1785. Although these two geisha are women, the term originally applied to men who provided entertainment in the pleasure quarters prior to a client visiting a courtesan. By the mid-eighteenth century, most geisha were women.

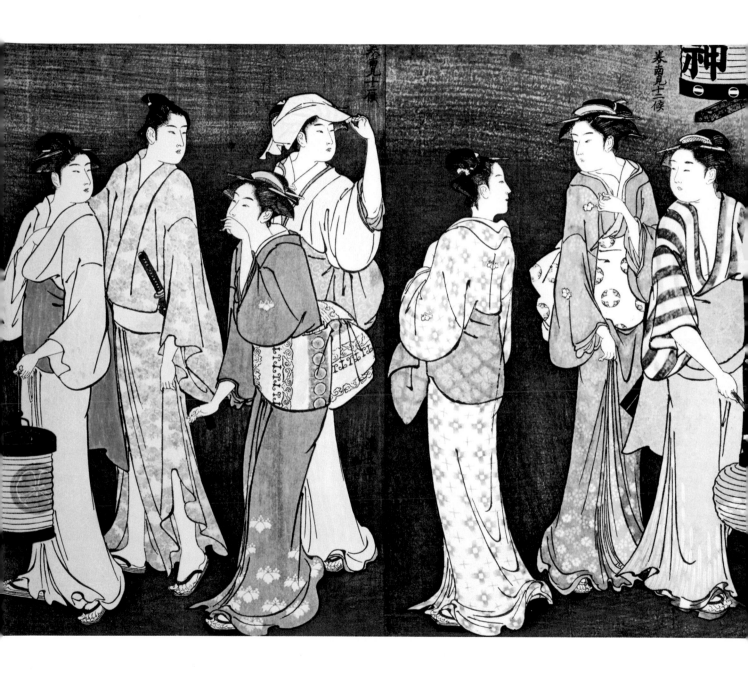

Print by Torii Kiyonaga (1752–1815)
Colour woodblock print
• Private Collection

Night Scene in Shinagawa, 1785. Shinagawa would have been the first 'station' at which travellers rested en route to Kyoto when walking along the coastal Tōkaidō Highway. This area of land was reclaimed from the sea during the Edo period to create the 'station'.

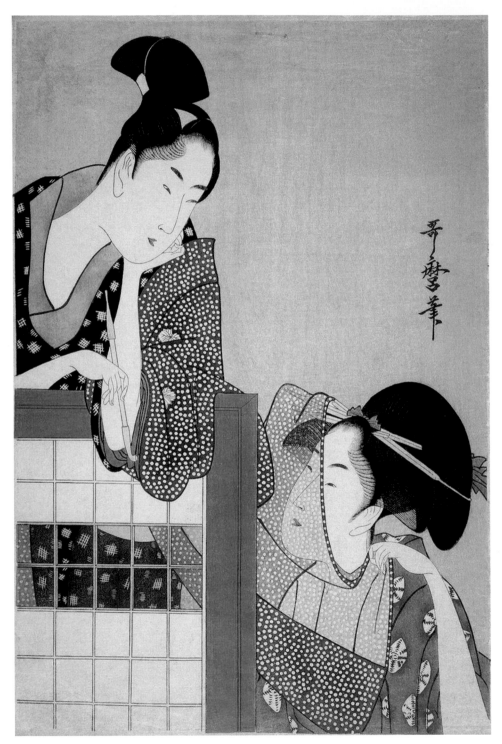

Print by Kitagawa Utamaro (1753–1806)
Colour woodblock print
• The State Hermitage Museum, St Petersburg

Two Ladies, 1797. The lady on the left is seen holding a *kiseru* pipe, used for smoking a thinly shredded tobacco product called *kizami*. Each end is made from metal, with the central part being made of bamboo cane.

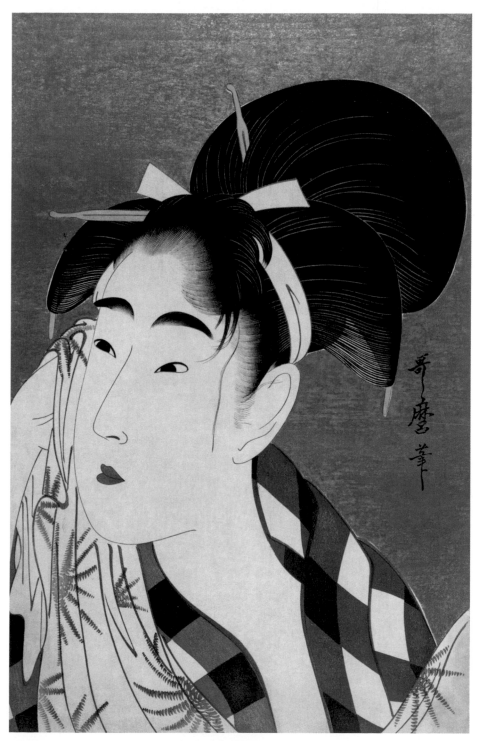

Print by Kitagawa Utamaro (1753–1806)
Colour woodblock print
• The Pushkin Museum of Fine Arts, Moscow

Portrait of a Young Woman, 1798. This is a sensuous portrayal of a young woman, influenced by the graceful lines of the artist's near contemporary, Torii Kiyonaga. Note the use of bright colour, which is restricted to the *kanzashi* hair ornaments and the lipstick.

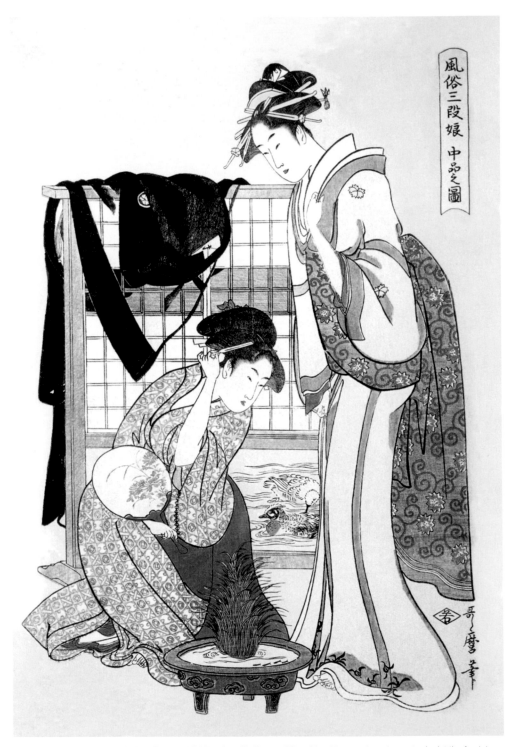

風俗三段娘 中品之圖

Print by Kitagawa Utamaro (1753–1806)
Colour woodblock print

Middle-class Mother and Daughter. Utamaro has chosen to depict the feminine aspects of the burgeoning middle classes in late-eighteenth-century Edo, a domestic scene usually only accessible to the women of the household.

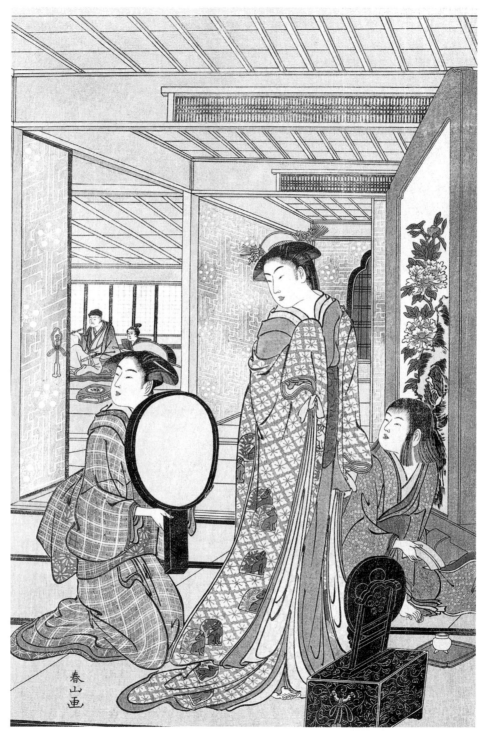

Print by Katsukawa Shunshō (1726–93)
Colour woodblock print

Woman in Front of a Mirror, 18th century. Shunshō produced very few prints of *bijin-ga*, preferring the medium of painting for this genre. This print was part of a series in which courtesans are depicted in their so-called 'green houses' in the pleasure district.

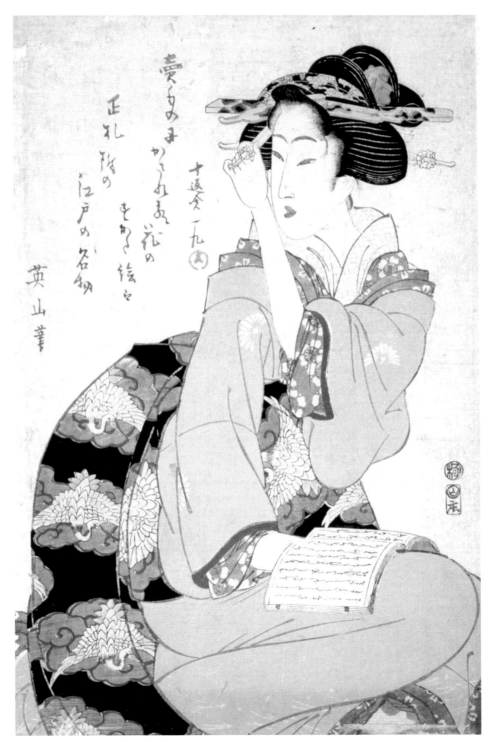

Print by Kikugawa Eizan (1787–1876)
Colour woodblock print

Geisha Reading a Book, 19th century. Unusually for the time, Eizan was a left-handed artist. Like his contemporaries of *bijin-ga*, he used a sensuous curvilinear line in his portrayals of women, that predates Art Nouveau by nearly a hundred years.

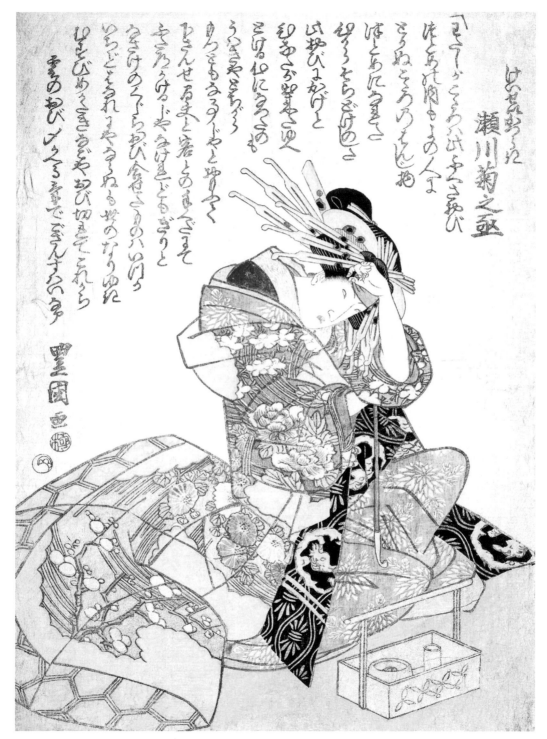

Print by Utagawa Toyokuni (1769–1825)
Colour woodblock print

Woman with a Calligraphy Brush, 19th century. Calligraphy has been a key component of Japanese life since its introduction by the Chinese in the seventh century, and it is known as the *karayō* tradition. It was adapted in the Edo period to create the *edomoji* used in advertising.

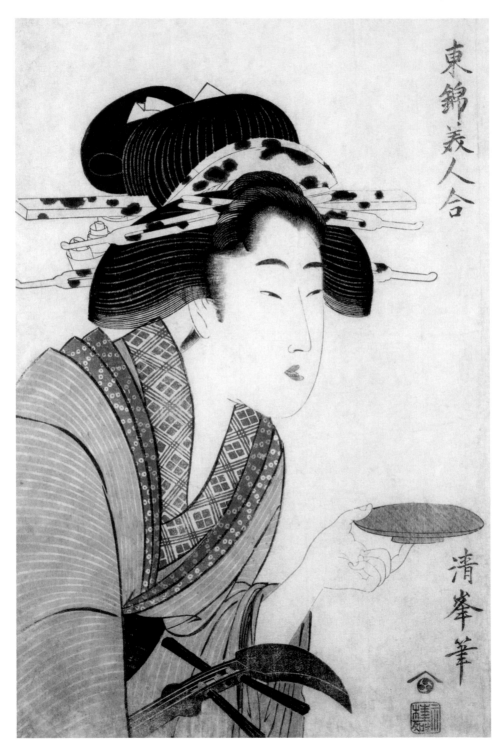

東錦羨人合

清峯筆

Print by Torii Kiyomine (1787–1868)
Colour woodblock print

Beauty with Sake Cup and Shamisen, 1810. This image is from a series of prints called
'Comparison of Beauties in Eastern Brocade', in which the woman is holding a cup for drinking
sake and a shamisen, a three-stringed musical instrument unique to Japan.

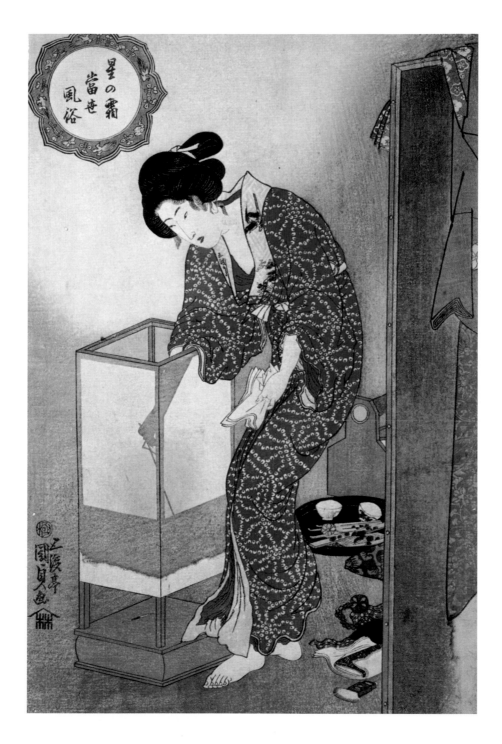

Print by Utagawa Kunisada (Toyokuni III) (1786–1865)
Colour woodblock print
• Private Collection

Beauty Beside a Standing Lantern, 1818–20. Kunisada depicts a courtesan, in her flimsy under-kimono, lighting a paper lantern. The presence of the two cups in the background suggests she is currently entertaining a client, who is possibly behind the screen.

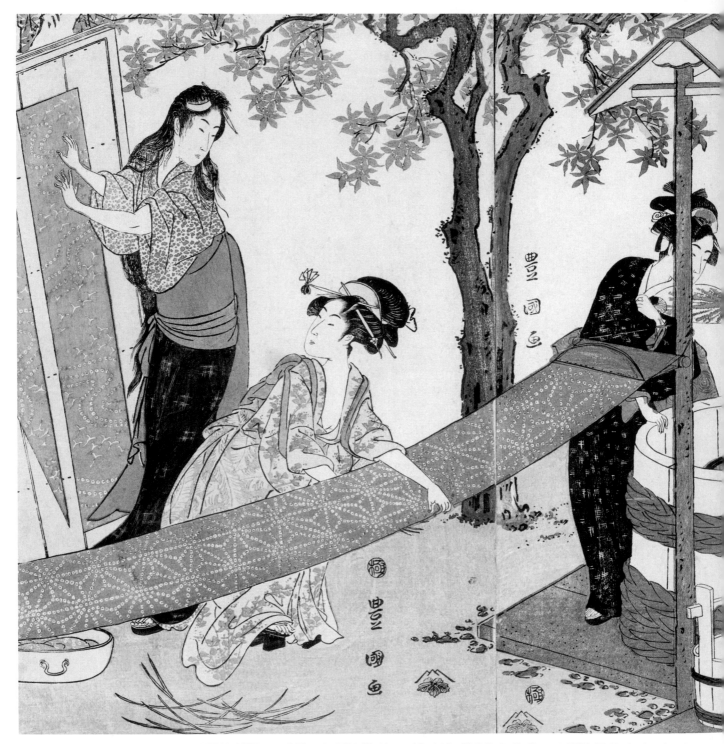

Triptych by Utagawa Toyokuni (1769–1825)
Colour woodblock print, 37.7 x 25.3 cm (14⅞ x 10 in)
• Private Collection

A Triptych of Girls Washing and Stretching Cloth Under the Trees, *c.* 1795–99. Toyokuni produced a number of triptych designs depicting everyday events. The central and right-hand panels demonstrate his interest in the use of Western perspective techniques, a key feature of *ukiyo-e* in the nineteenth century.

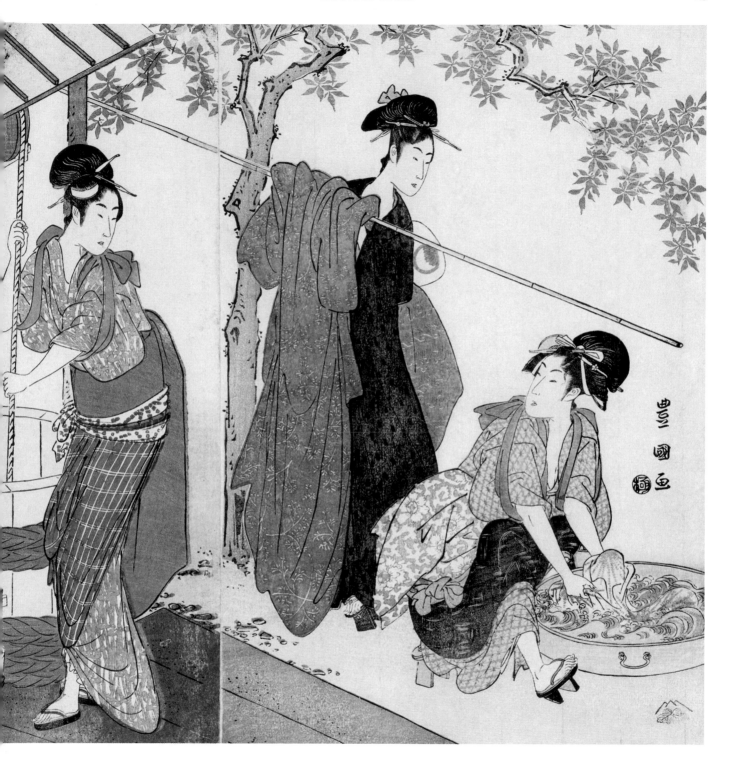

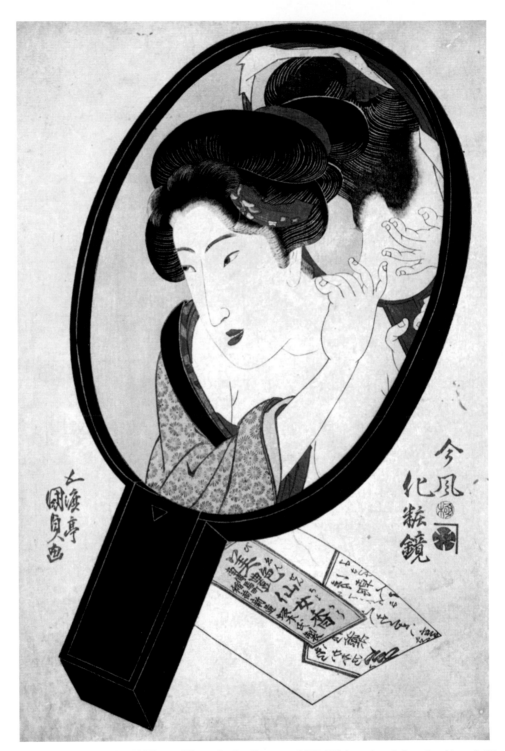

Print by Utagawa Kunisada (1786–1865)
Colour woodblock print
• Private Collection

Mirrors: Getting Glamorous, 1823. This image is part of a series of ten called 'Imafu Kesho Kagami', or 'Mirrors of Modern Make-up', and the signature on the left reads 'Gototei Kunisada'. Note the fine engraving techniques used in the hair detailing, a key feature of good *ukiyo-e*.

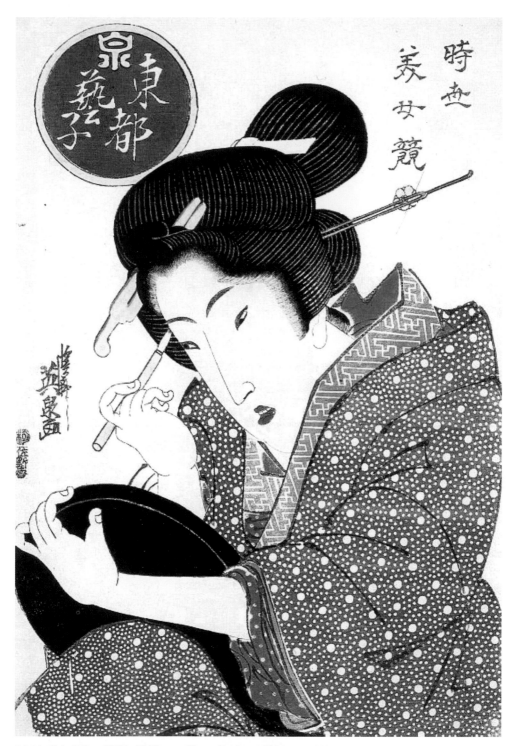

Print by Keisai Eisen (1790–1848)
Colour woodblock print, 37.8 x 26.4 cm (14⅞ x 10⅜ in)
• The Pushkin Museum of Fine Arts, Moscow

Woman Putting on Make-up, *c.* **1830.** This *bijin-ga* is shown applying make-up in the traditional Japanese manner of the Edo period, the thin lines of the eyebrows painted on to an applied thick layer of white lead foundation.

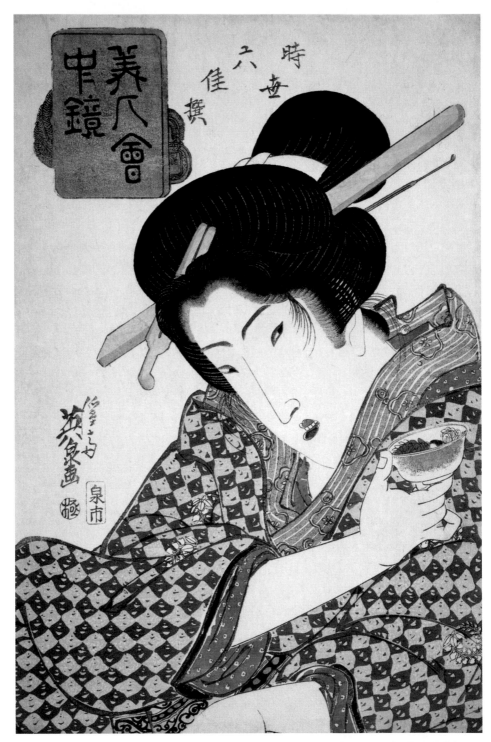

Print by Keisai Eisen (1790–1848)
Colour woodblock print

Half-length Portrait of a Young Woman with a Cup in her Hand, 1830. From the series 'Contest between Contemporary Beauties', this *bijin-ga* is typical of Eisen's oeuvre, the so-called *ōkubi-e* or large head pictures. Note the detailing on the woman's kimono.

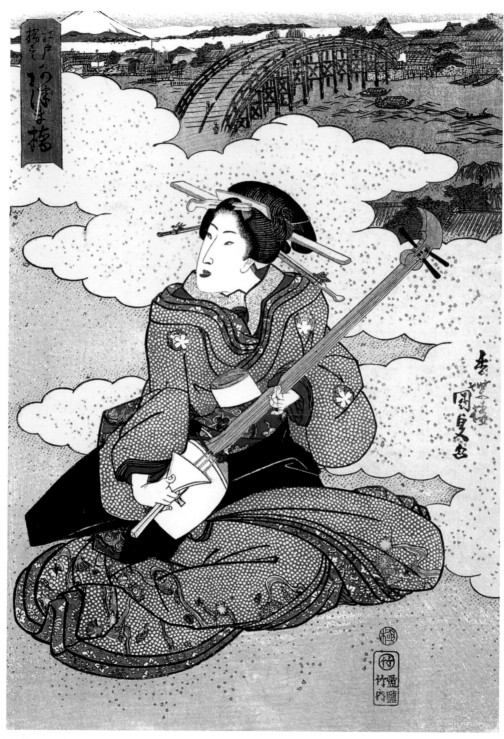

Print by Utagawa Kunisada (1786–1865)
Colour woodblock print
• Private Collection

Woman Playing. The woman depicted here is playing a shamisen, a three-stringed instrument plucked using a plectrum called a *bachi*. The soundbox of the instrument is similar to a banjo and is made from animal skin.

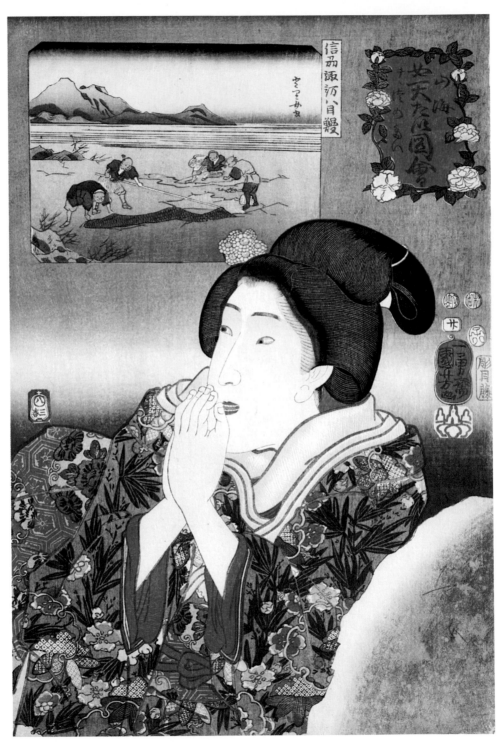

Print by Utagawa Kuniyoshi (1797–1861)
Colour woodblock print, 37.1 x 25 cm (14⅝ x 9⅞ in)
• Museum of Fine Arts, Boston

'Oh how cold': The Province Shinano, 1852. This woman appears to be reacting to the image pasted on the wall behind her, which depicts four men cleaning their fishing nets on the shore. The image is from the series 'Celebrated Treasures of Mountains and Seas'.

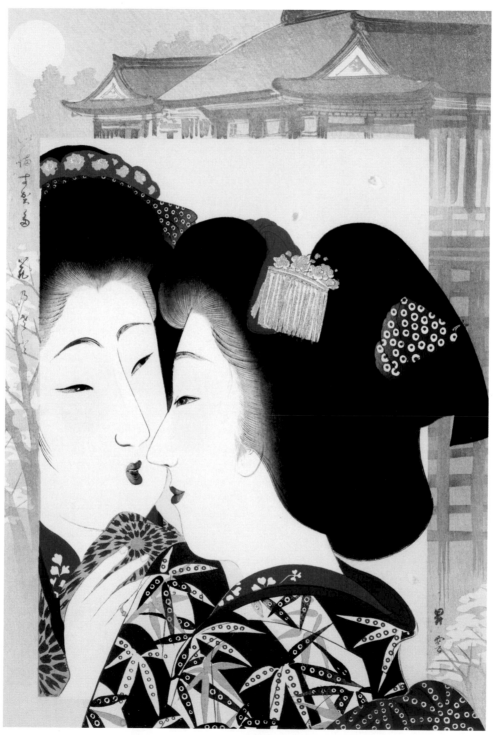

Print by Yamamoto Shōun (1870–1965)
Colour woodblock print
• Private Collection

Two Geisha at the Temple, 1906–09. This image is one of a series made by Shōun called simply 'Fashions of Today', designed to give women an idea of the latest fashion trends. The series comprised 15 prints in this format, and 13 half-length portraits.

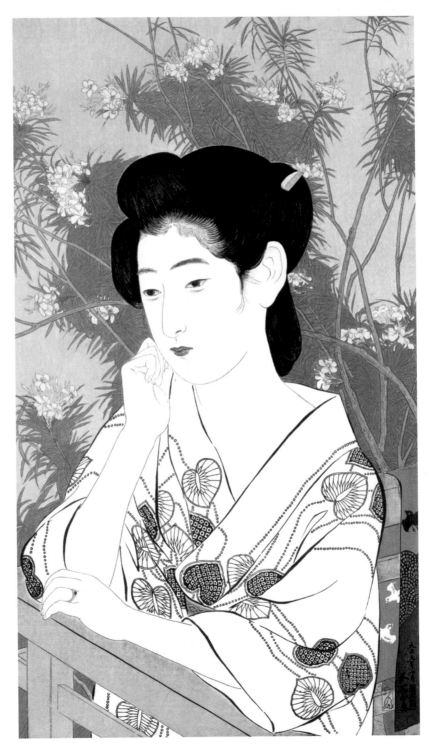

Print by Hashiguchi Goyō (1880–1921)
Colour woodblock print
• 45.2 x 24.8 cm (17⅞ x 9¾ in)

Hot Spring Inn, 1920. Goyō has chosen to keep the figure and her kimono in simple monochrome tones, the bright background acting as a foil. This style differs from previous generations of *ukiyo-e* artists by using simple sinuous lines to suggest her beauty.

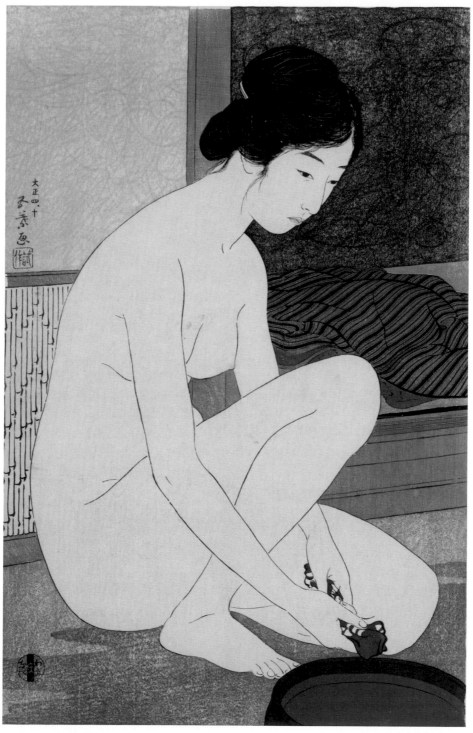

Print by Hashiguchi Goyō (1880–1921)
Colour woodblock print
• Honolulu Museum of Art, Honolulu

Woman After a Bath, 1920. Goyō was the master of *shin-hanga* prints, as seen in this example, combining traditional *ukiyo-e* printmaking with Western notions of the ideal female form. The fine-line technique used holds similarities to the work of Henri Matisse (1869–1954).

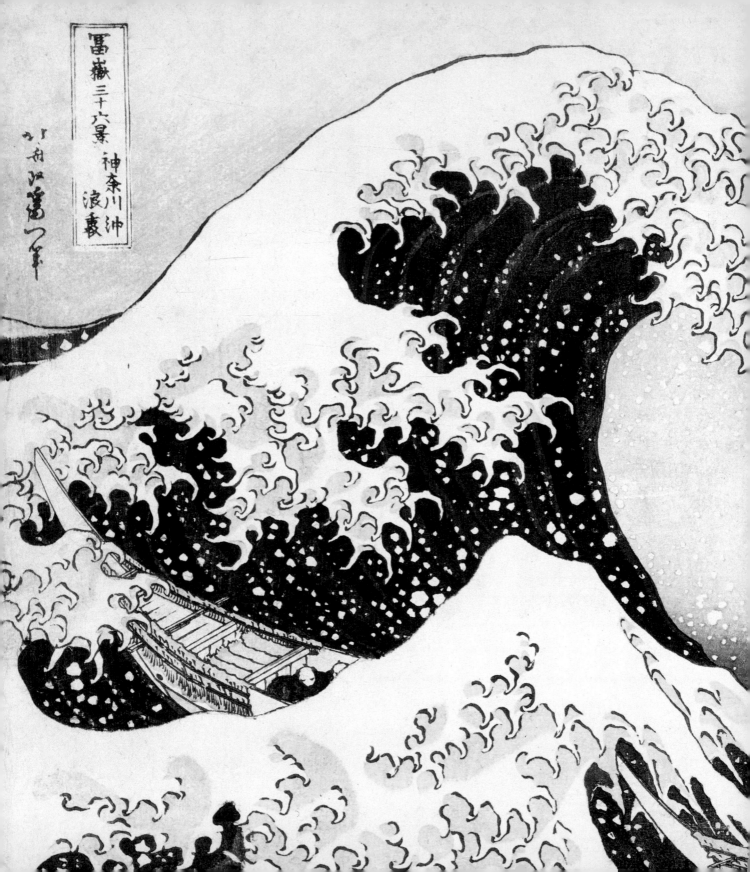

Landscapes

In the early years of *ukiyo-e*,
landscapes provided a backdrop
to the depiction of figures. Later
on, artists began to explore
the Japanese landscape as a
subject in its own right.

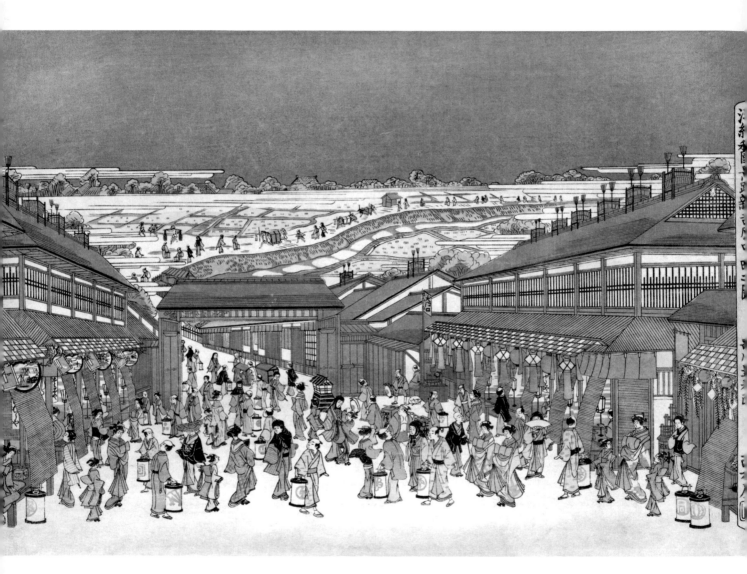

Print by Utagawa Toyoharu (1735–1814)
Colour woodblock print

Nakanocho in Shin-Yoshiwaro, *c.* 1775. This image depicts the hedonistic Yoshiwara district of Edo. It is an early example of the assimilation of Western perspectives in *ukiyo-e,* from a series created by Toyoharu called 'Perspective Views of Famous Places of Japan'.

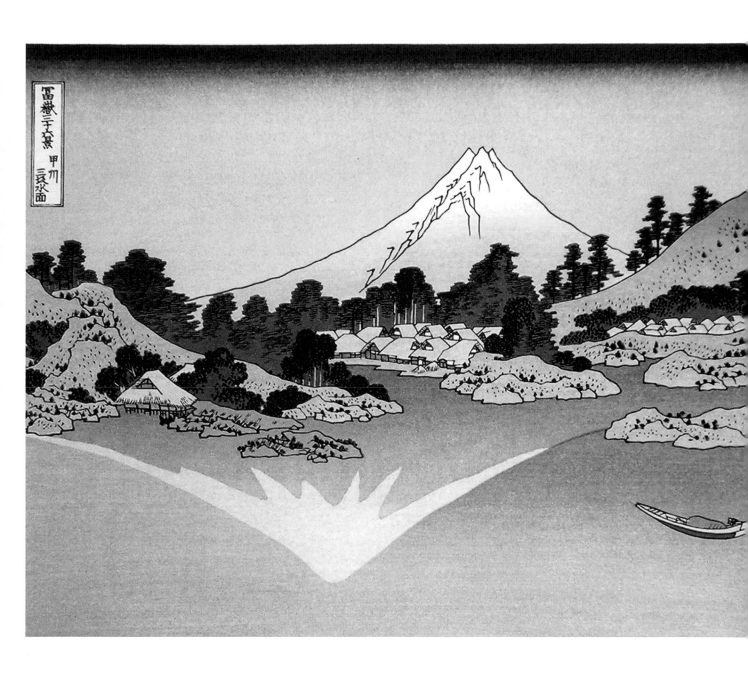

Print by Katsushika Hokusai (1760–1849)
Colour woodblock print, 37.5 x 25.3 cm (14⅞ x 10 in)
• British Museum, London

Reflection in the Surface of the Water, Misaka, Kai Province, 1830–33. Making up one of the five Fuji lakes, Lake Kawaguchi reflects the distinct snow-covered image of Mount Fuji as seen from the Misaka Pass. This is one of Hokusai's famous 'Thirty-six Views of Mount Fuji'.

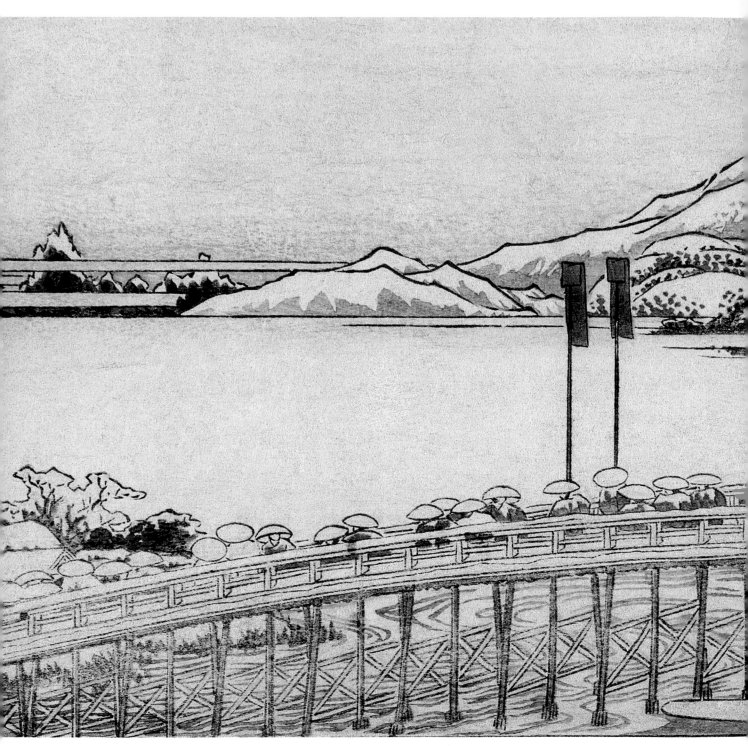

Print by Katsushika Hokusai (1760–1849)
Colour woodblock print, 12.5 x 36.2 cm (4⅞ x 14⅜ in)
• Amherst College, Amherst

Okazaki, 1804. This is one of the earliest landscapes executed by Hokusai as part of his series of 'The Fifty-three Stations of the Tōkaidō'. The Yahagigashi is shown in the foreground and was one of the longest bridges built in the Edo period.

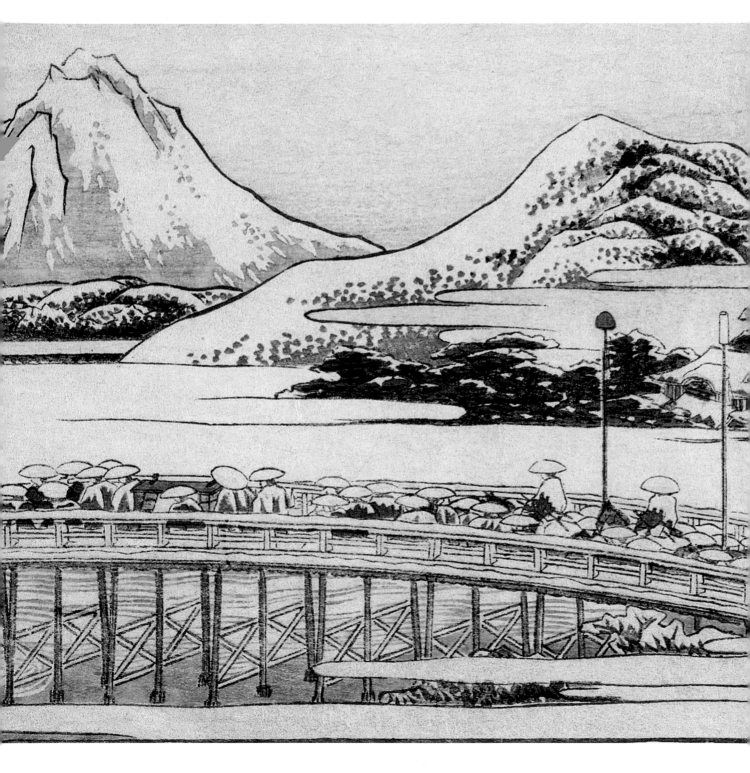

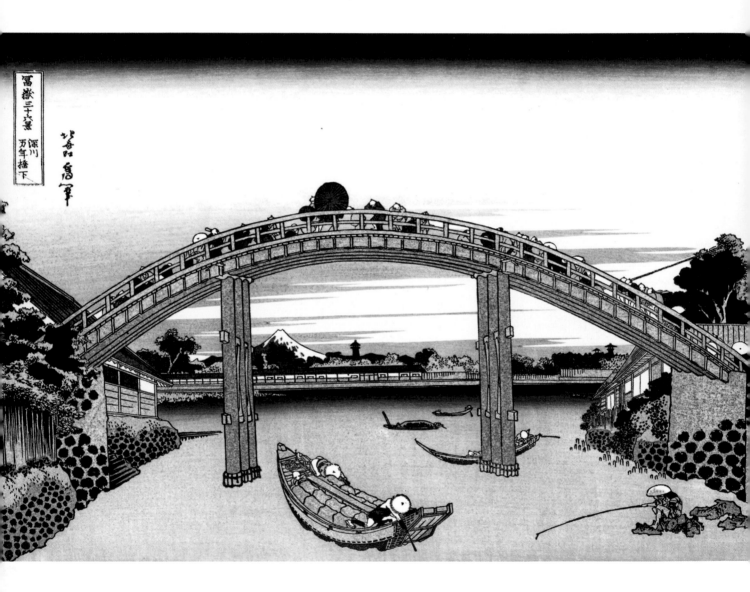

Print by Katsushika Hokusai (1760–1849)
Colour woodblock print, 25.7 x 37 cm (10¹⁄₁₀ x 14⅗ in)
• Honolulu Museum of Art, Honolulu

Under Mannen Bridge at Fukagawa, 1830–33. One of the 'Thirty-six Views of Mount Fuji' series, this print depicts the wooden Mannen Bridge spanning the Onagigawa River, which flows into the main Sumida River.

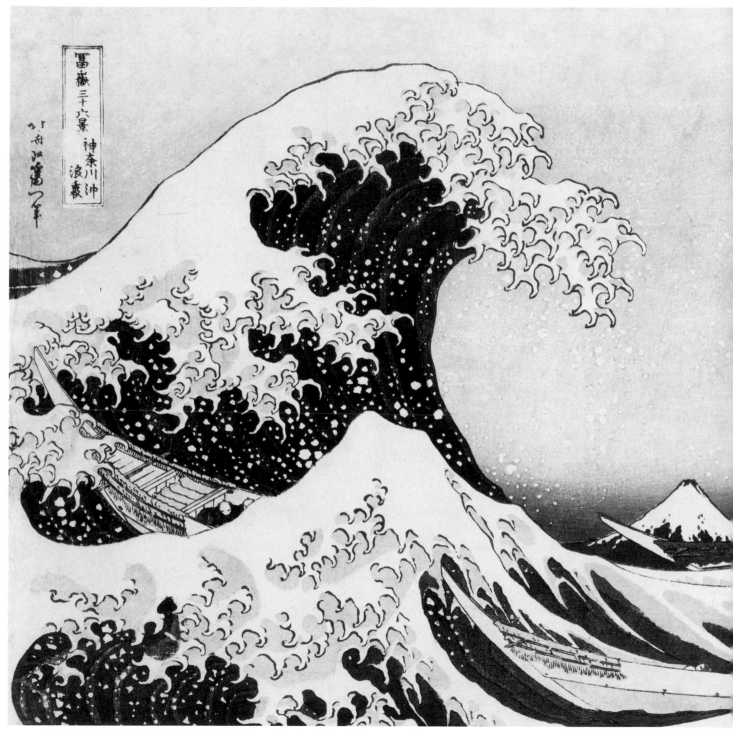

Print by Katsushika Hokusai (1760–1849) (detail)
Colour woodblock print, 23.8 x 36.6 cm (9⅜ x 14⅞ in)
• Museum of Fine Arts, Boston

The Great Wave off Kanagawa, 1831. This print is probably the most iconic image by Hokusai. It has been reproduced many times in different formats and is still popular today. It is signed by the artist in the top left-hand corner of the picture.

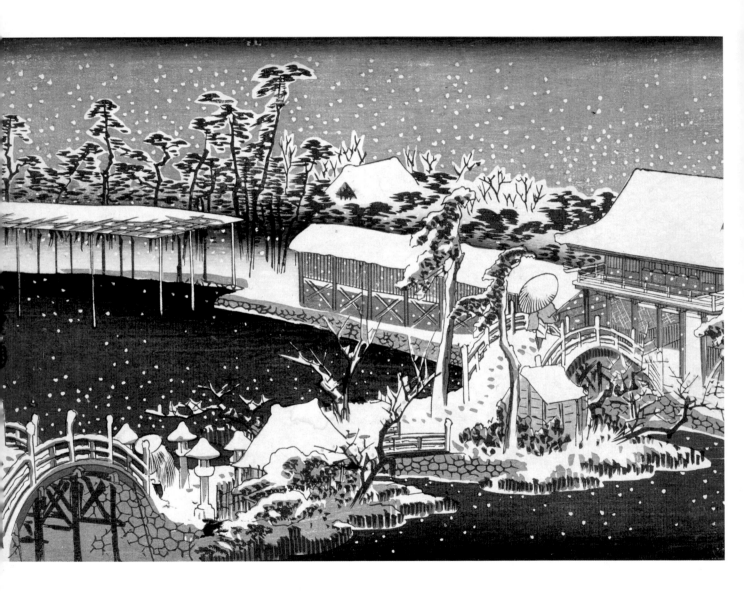

Print by Utagawa Hiroshige (1797–1858)
Colour woodblock print

Snow in the Precincts of the Temman Shrine at Kameido, 1831. An image from the series 'Famous Places of the Eastern Capital', this print shows a holy and revered site set by the little drum bridge, which was created in the seventeenth century and attracted many visitors in the Edo period.

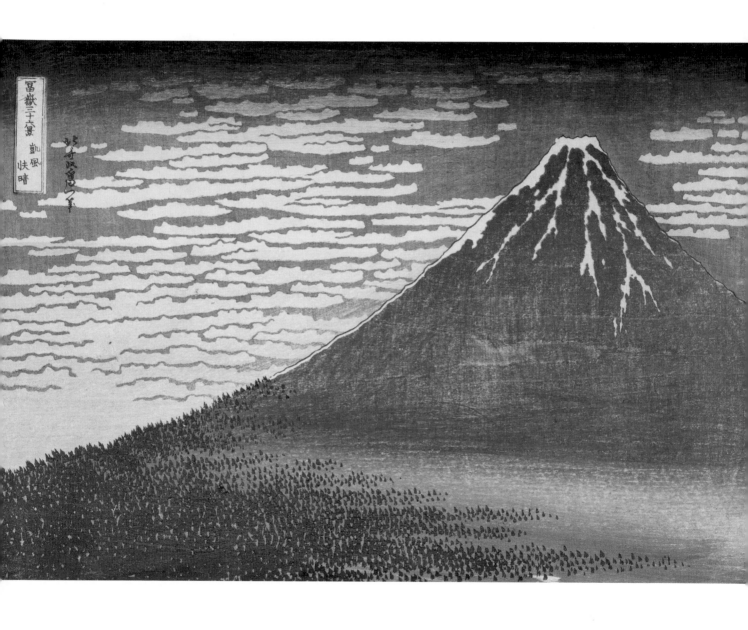

Print by Katsushika Hokusai (1760–1849)
Colour woodblock print, 26.1 x 38.2 cm (10⅕ x 15 in)
• Private Collection

Red Fuji, 1831. The correct title for this work is *Gaifu Kaisei*, which means 'fine wind, clear sky', but it is usually referred to as *Red Fuji*, and was the second image designed in the series 'Thirty-six Views of Mount Fuji'.

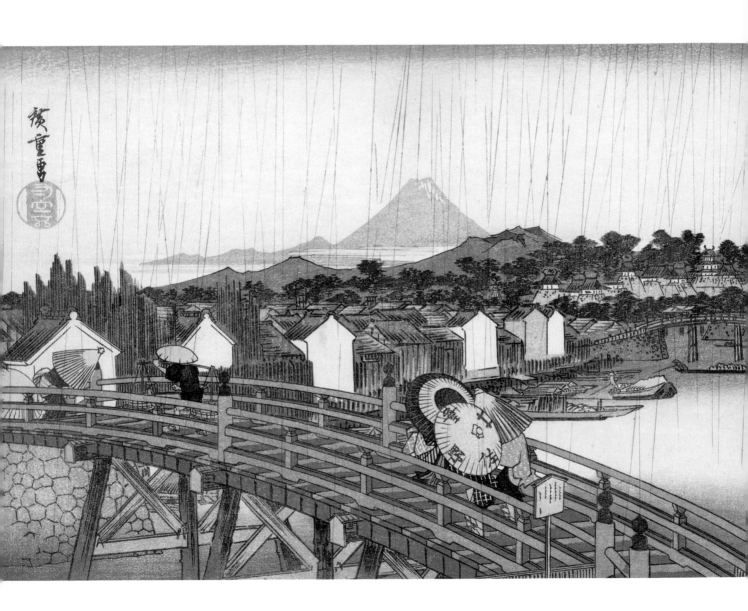

Print by Utagawa Hiroshige (1797–1858)
Colour woodblock print, 26.2 x 38.7 cm (10⅜ x 15¼ in)
• Brooklyn Museum, New York

Evening Shower at Nihonbashi Bridge, *c.* **1832.** Often referred to as the Edo Bridge, this wooden structure was erected in 1603 at the Eastern end of the Tōkaidō Road. The bridge was replaced in 1911 by a stone one. This work is from the series 'Famous Places of the Eastern Capital'.

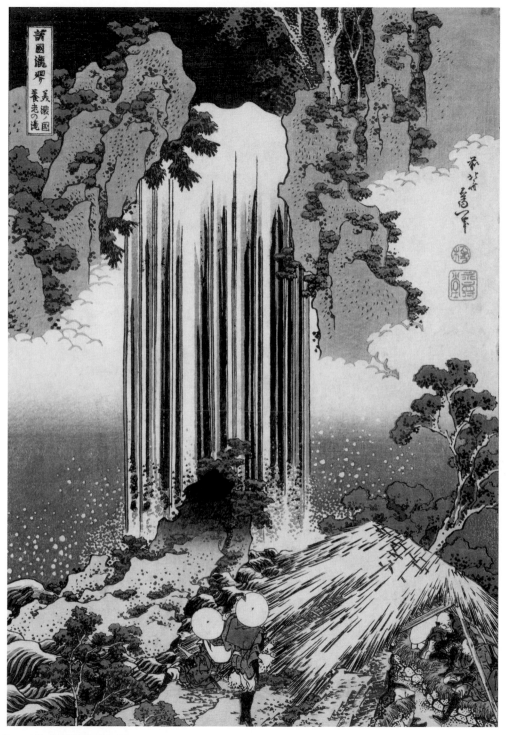

Print by Katsushika Hokusai (1760–1849)
Colour woodblock print
• 38.2 x 25.4 cm (15 x 10 in)

The Yoro Waterfall, Mino Province, *c.* 1833. One of a series of eight prints entitled 'A Journey to the Waterfalls of All the Provinces', these falls are 32 m (105 ft) high and located in the *Gifu* prefecture, one of the few landlocked areas in Japan.

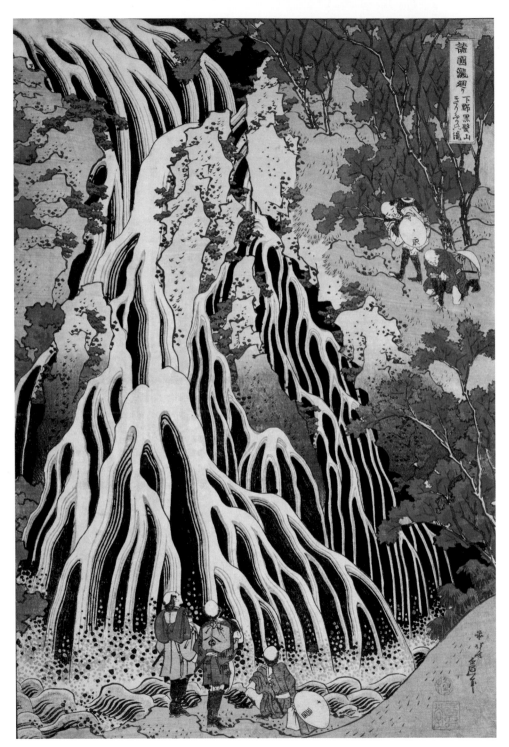

Print by Katsushika Hokusai (1760–1849)
Colour woodblock print, 37.6 x 25.7 cm (14⅞ x 10⅛ in)
• Philadelphia Museum of Art, Philadelphia

The Kirifuri Waterfall at Mount Kurokami, *c.* 1833. This image shows tourists come to explore the 500 m- (1,640 ft-) high mountain and falls at Kurokami. Internal tourism had become very popular in Japan in the nineteenth century, since its citizens were forbidden to travel abroad at this time.

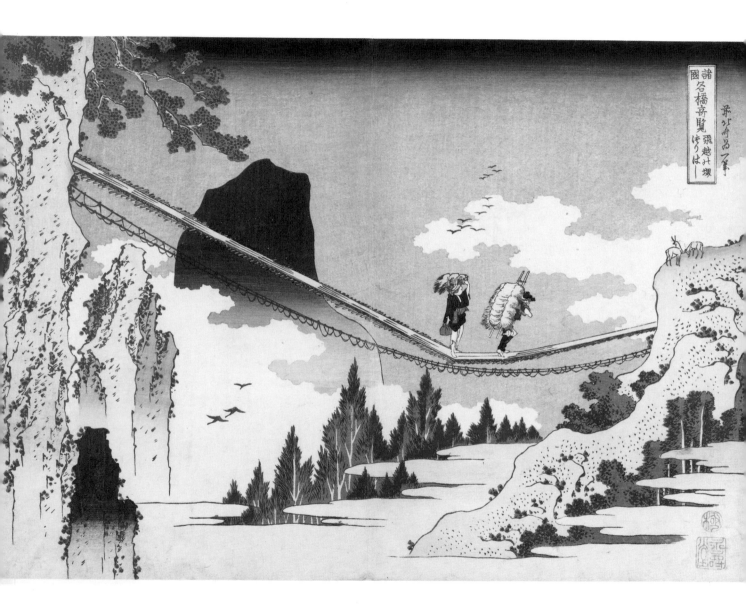

Print by Katsushika Hokusai (1760–1849)
Colour woodblock print, 25.3 x 37.6 cm (9¹⁵⁄₁₆ x 14¹³⁄₁₆ in)
• Minneapolis Institute of Arts, Minneapolis

Suspension Bridge between Hida and Etchū Provinces, 1833–34. One of 11 images from the series 'Wondrous Views of Famous Bridges in All the Provinces', this one is the most sublime, due to the precarious nature of the bridge that appears to not even have a handrail.

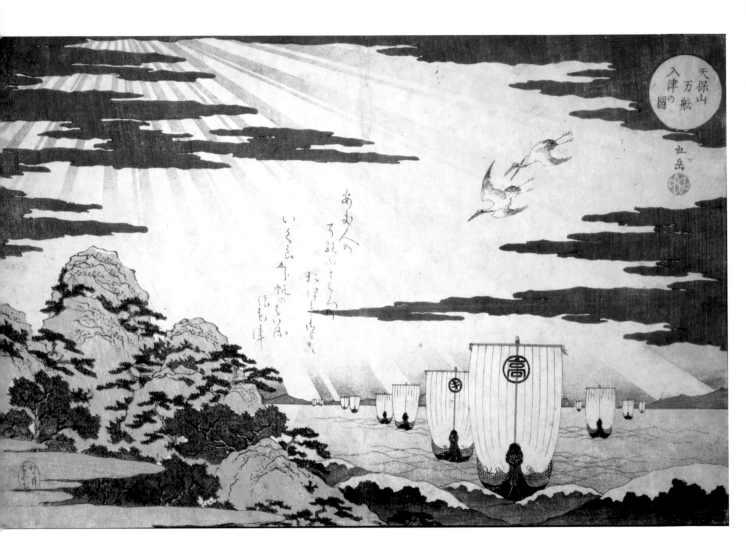

Print by Yashima Gakutei (1786–1868)
Colour woodblock print
• Private Collection

Ships Returning to Harbour at Tempozan, 1838. Gakutei was originally from Osaka, the subject of this print. Note the rising sun motif in the background, a symbol of military strength in the Edo period, and later adapted as Japan's national flag.

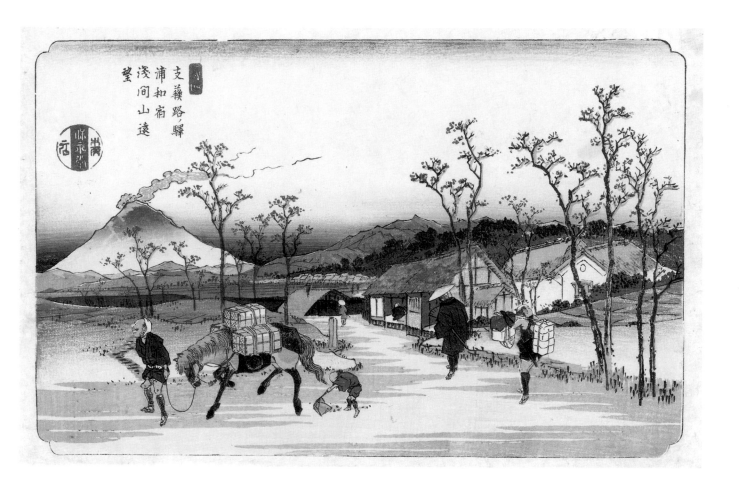

Print by Keisai Eisen (1790–1848)
Colour woodblock print, 24 x 36.8 cm (9⅜ x 14½ in)
• Private Collection

Distant View of Mount Asama from Urawa Station, late 1830s. This is number four from the series 'Sixty-nine Stations of the Kiso Highway', which was started by Eisen and completed by Hiroshige. Mount Asama is an active volcano, which had erupted about 50 years prior to this image being made.

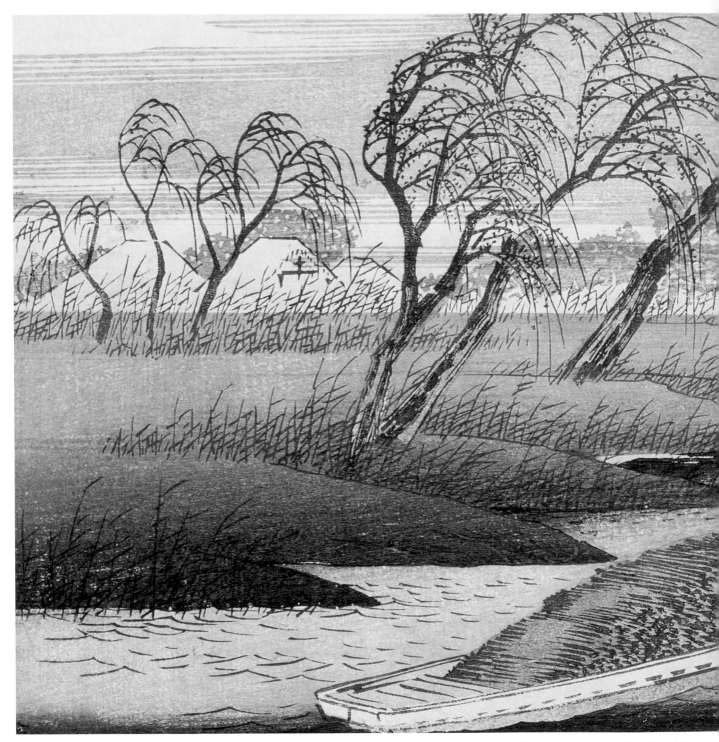

Print by Utagawa Hiroshige (1797–1858)
Colour woodblock print
• Musée Guimet, Paris

Full Moon at Seba, *c.* **1837–42.** An image from the series 'Sixty-nine Stations of the Kiso Highway', this moonlit scene depicts two rivermen using poles to steer and propel their cargo-laden sampans along the river.

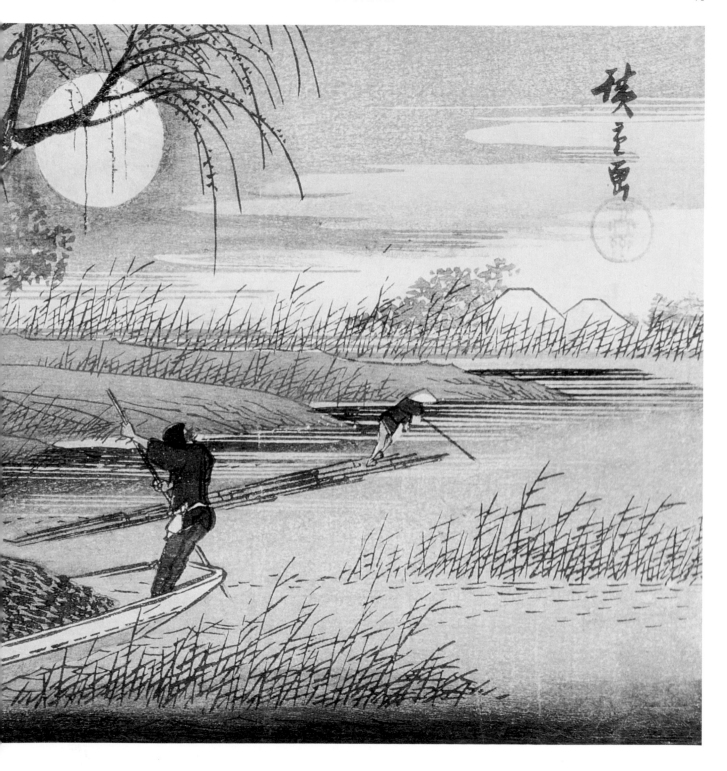

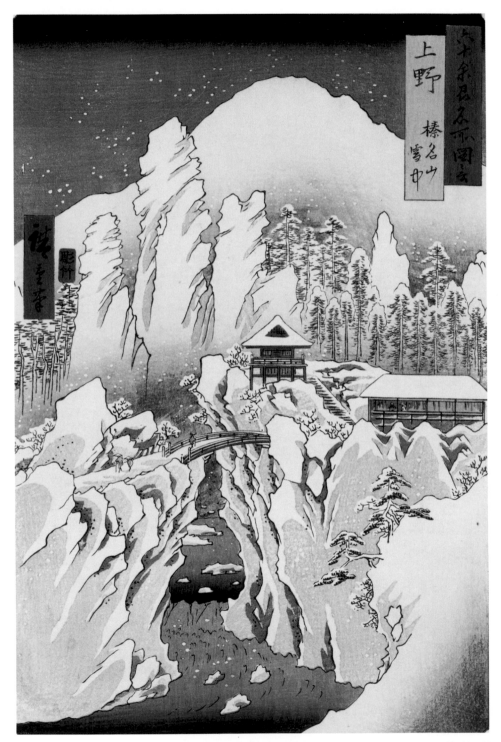

Print by Utagawa Hiroshige (1797–1858)
Colour woodblock print
• 33 x 24.1 cm (13 x 9½ in)

Mount Haruna in Snow, 1853–56. This is one of 70 prints executed by Hiroshige between 1853 and 1856 for the series 'Famous Places: The Sixty-odd Provinces'. Mount Haruna is an inactive volcano with its own crater lake.

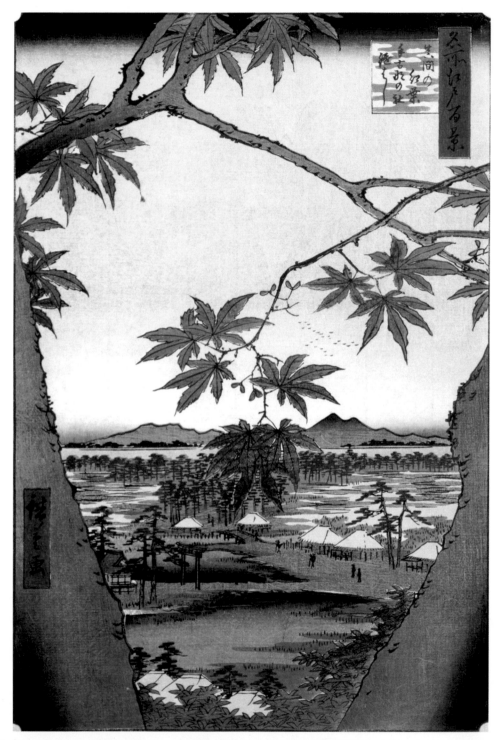

Print by Utagawa Hiroshige (1797–1858)
Colour woodblock print, 34 x 22.2 cm (13⅜ x 8¾ in)
• Brooklyn Museum, New York

Mama Maple Trees with Tekona Shrine and Bridge, 1856–58. This print is from the series 'One Hundred Famous Views of Edo'. During the nineteenth century, large numbers of visitors came to this site at Mama, a small town ten miles east of Edo, just to admire the maple trees in the autumn.

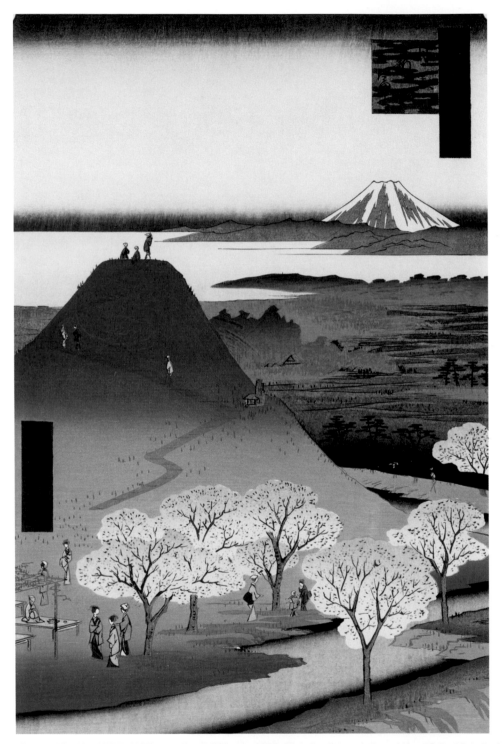

Print by Utagawa Hiroshige (1797–1858)
Colour woodblock print, 34.1 x 22.9 cm (13⅜ x 9 in)
• Brooklyn Museum, New York

New Fuji Meguro, 1856–58. In the distance is the real Mount Fuji, while in the foreground is one of a number of smaller manmade versions, which was much easier for people to climb during annual spiritual pilgrimages. The imitation of Fuji depicted in this print was built in 1819.

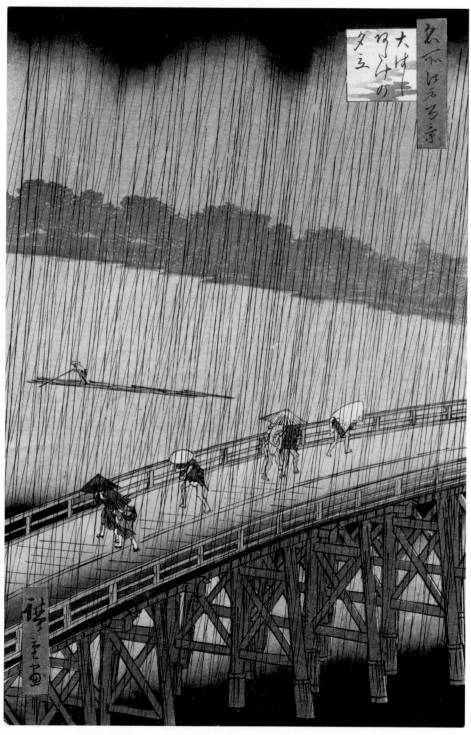

Print by Utagawa Hiroshige (1797–1858)
Colour woodblock print, 33.7 x 22.2 cm (13¼ x 8¾ in)
• Brooklyn Museum, New York

Ōhashi, Sudden Shower at Atake, 1856–58. Ōhashi literally means 'large bridge', suggesting there is little or no shelter for these pedestrians until they reach the end of it. The image is one of the series 'One Hundred Views of Famous Places in Edo'.

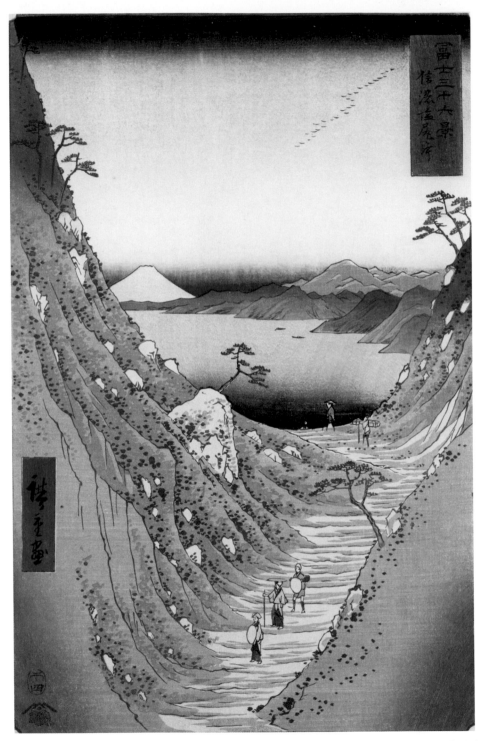

Print by Utagawa Hiroshige (1797–1858)
Colour woodblock print, 33.8 x 22.3 cm (13⅜ x 8⅞ in)
• Spencer Museum of Art, Lawrence, Kansas

Shiojiri Pass in Shinano Province, 1858. This view across to Mount Fuji is from the northern side, Shiojiri Pass being one of the stations along the Kiso Highway. This print, however, is in the series 'Thirty-six Views of Mount Fuji'.

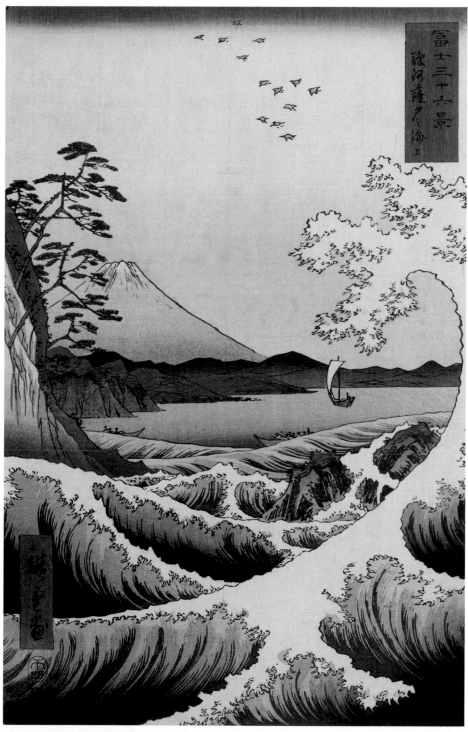

Print by Utagawa Hiroshige (1797–1858)
Colour woodblock print, 35.4 x 24.3 cm (14 x 9½ in)
• The British Museum, London

Waves off the Satta Pass in Suruga Province, 1858. Hiroshige is clearly paying homage to Hokusai's *Great Wave off Kanagawa* in this image from his own series 'Thirty-six Views of Mount Fuji', published in the year of his death.

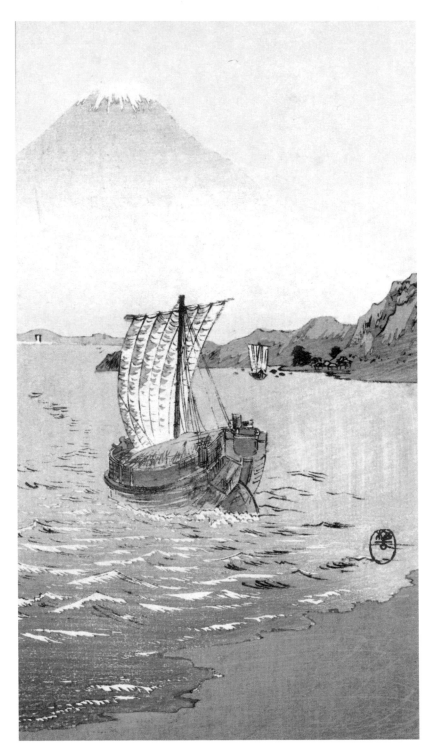

Print by Shokoku Yamamoto (1870–1965)
Colour woodblock print

Boat Sailing Away from the Shoreline, Mount Fuji in the Background, *c.* **1900–20.** Despite its publication in the twentieth century, this print is more akin to the *ukiyo-e* images of the eighteenth century, with its simple outlines and pale colouring.

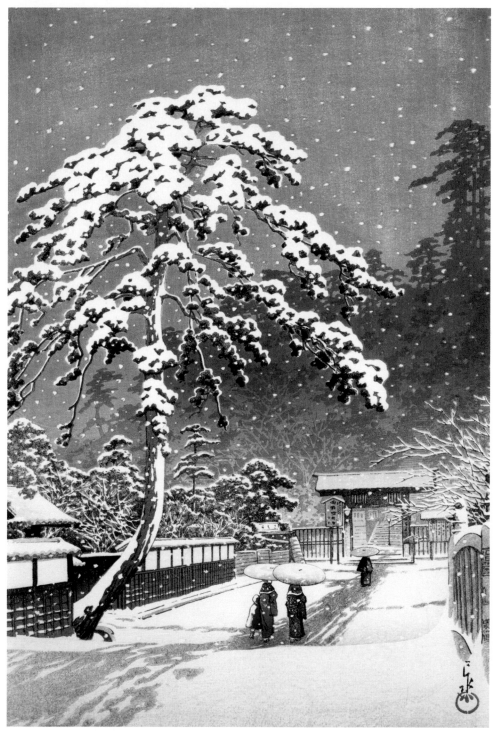

Print by Hasui Kawase (1883–1957)
Colour woodblock print

Mon Hon Temple at Ikegami under the Snow, 1931. The Mon Hon Temple was erected in the seventeenth century on the site where the twelfth-century Buddhist monk Nichiren died. The *kyōzō*, where the religious artefacts are kept, was added in the eighteenth century.

Kabuki Theatre

The most charismatic of all *ukiyo-e* subjects are the actors of the kabuki theatre, often depicted as particular characters, but who in their own right were the celebrities of the Edo period.

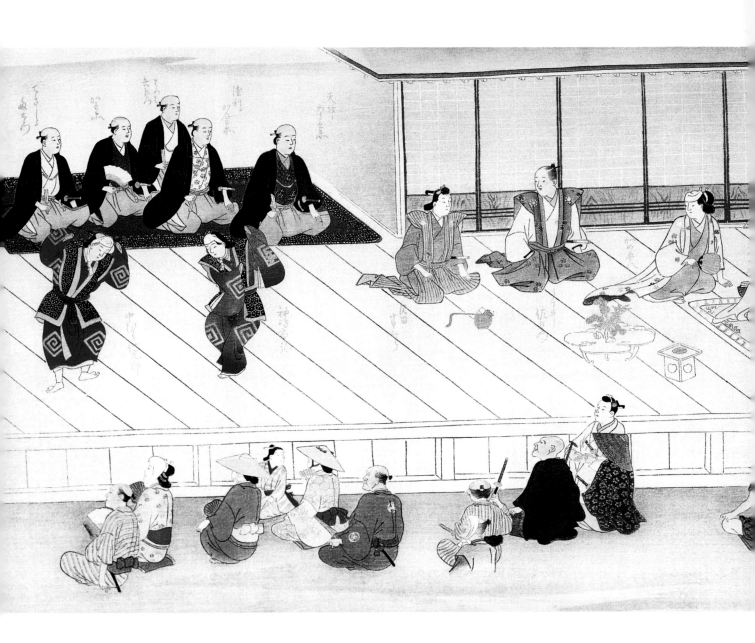

Print by Hishikawa Moronobu (?1618–94)
Colour woodblock print

Futari Saruwaka, scene from a theatre play, 17th century. Unusually, the viewer of this image can see the audience as well as the performers on stage, which suggests the importance of the interaction between the two at this time. Subsequent portrayals by later generations omit this interaction.

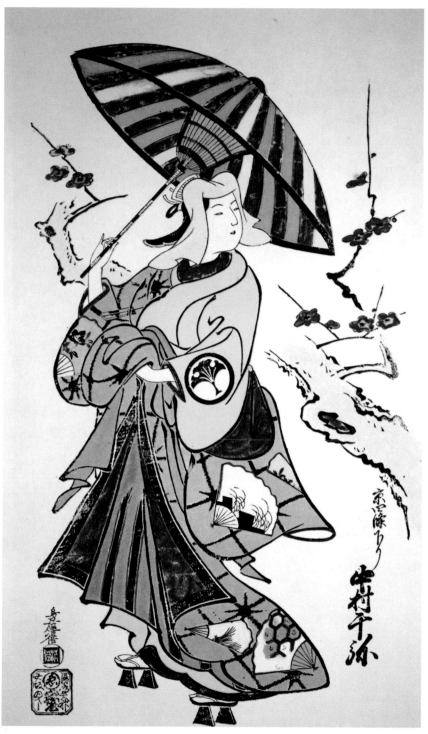

Print by Torii Kiyomasu I (active 1695–1720)
Colour woodblock print, 59.1 x 31.1 cm (24¼ x 12¼ in)
• Metropolitan Museum of Art, New York

The Actor Nakamura Senya in the Role of Tokonatsu, Walking with Sunshade, 1716. At this time, women's roles on stage were played by men, as shown in this image, and yet the artist manages to encapsulate the femininity of the role using sinuous lines in the design.

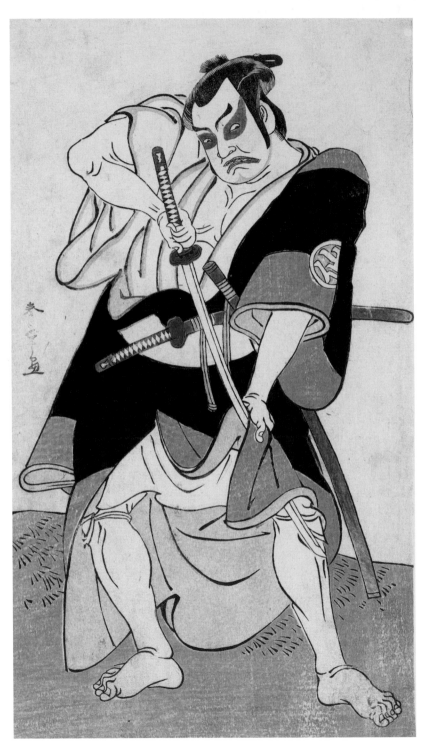

Print by Katsukawa Shunshō (1726–93)
Colour woodblock print, 32 x 14.8 cm (12½ x 5⅞ in)
• Smithsonian Institution, Washington

Kabuki Actor Nakamura Sukegoro II as a Samurai, late 1770s. The samurai were a warrior class until the Edo period brought an end to warfare and they gradually lost their power and became bureaucrats. This image looks back to a previous era in a stage performance.

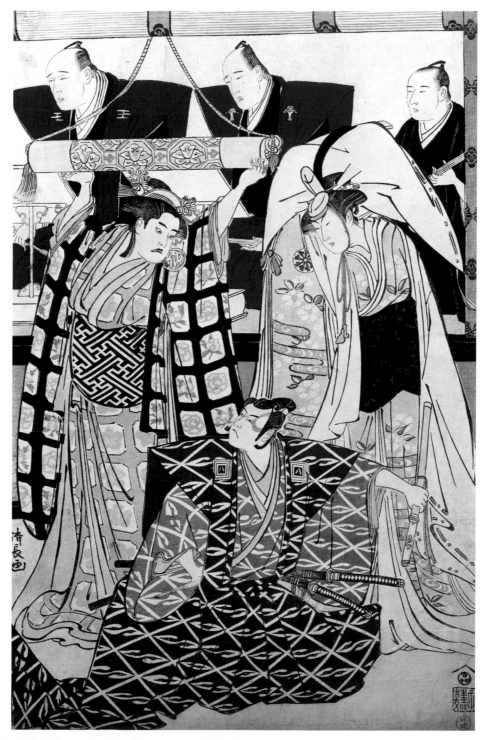

Print by Torii Kiyonaga (1752–1815)
Colour woodblock print

Actor, 1780–90. Kiyonaga continues the Torii school tradition of depicting kabuki actors in dramatic stage settings such as this, in which the protagonists use motionless poses to create tension for the audience.

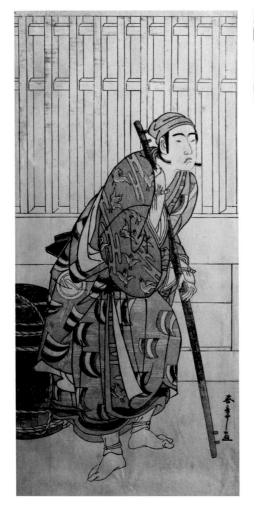
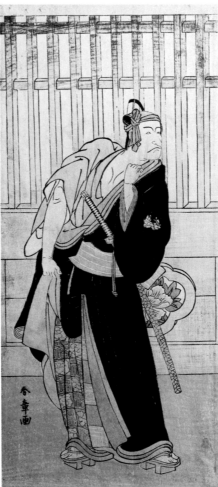
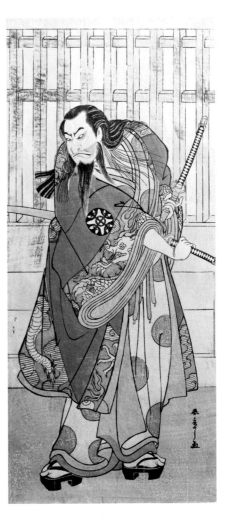

Print by Katsukawa Shunshō (1726–93)
Colour woodblock print, 32 x 15 cm (12⅝ x 5⅞ in)
• Museum of East Asian Art, Berlin

The Actors Riko Nakamura, Matsuke Onoe I and Nakazo Nakamura I, *c.* 1782. The right-hand panel of this triptych depicts Nakazo Nakamura I, who became famous for portraying villains on stage before developing his own style of performance known as *Hidetsuru*, which is still used today in Japanese theatre.

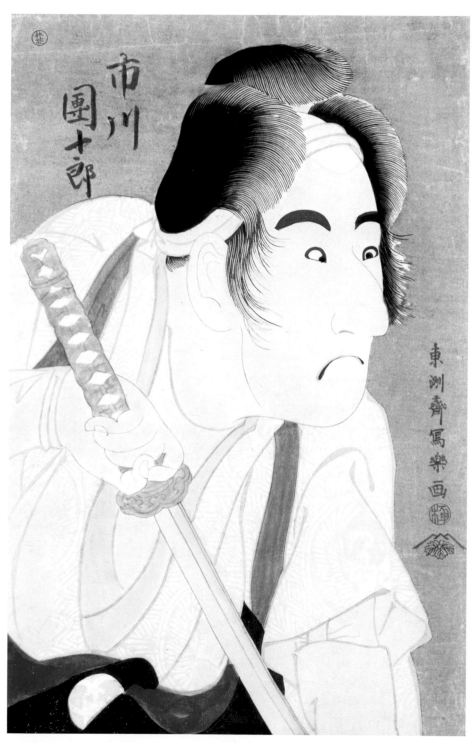

Print by Tōshūsai Sharaku (active 1794–95)
Colour woodblock print, 37.5 x 24.7 cm (14¾ x 9¾ in)
• Private Collection

The Actor Bando Mitsugoro II as Ishi Genzo, 1794. Sharaku's style is both aggressive and almost comedic. This is a dramatic moment in the play *The Iris Soga of the Bunroku Era*; Genzo has drawn his sword to avenge the murder of his father-in-law.

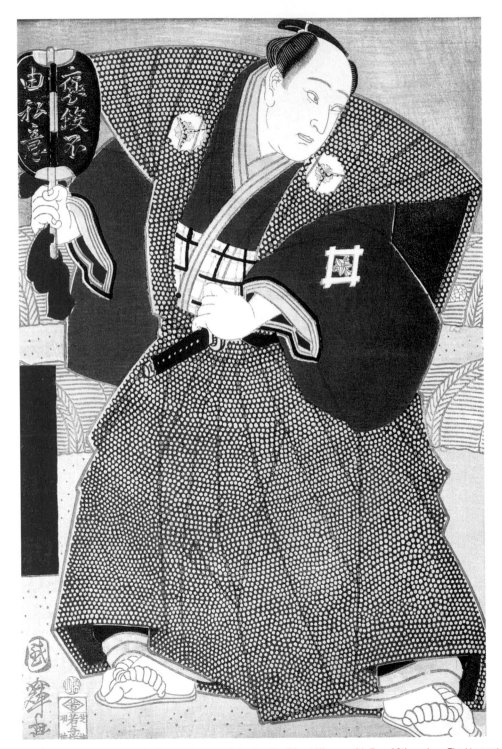

Print by Utagawa Toyokuni (1769–1825)
Colour woodblock print

Japanese Actor in a Traditional Kimono with Fan, 19th century. The kimono is a T-shaped garment worn by both men and women in Japan since around the eighth century. The garment is always wrapped left over right, regardless of sex, and tied with a sash called an *obi*.

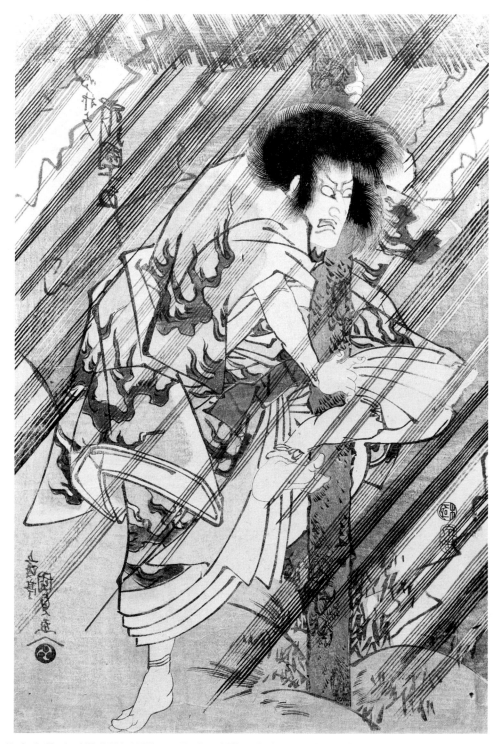

Print by Utagawa Kunisada (Toyokuni III) (1786–1865)
Colour woodblock print
• Professor Franz Winzinger Collection, Regensburg

The Actor Ichikawa Danjuro VII as Shirobei in a Thunderstorm, *c.* 1818. The son-in-law of the actor Danjuro VI, Ichikawa became arguably the greatest actor in nineteenth-century Edo, performing at the main theatres such as the Nakamura-za, until 1832, when he passed the Danjuro name to his son.

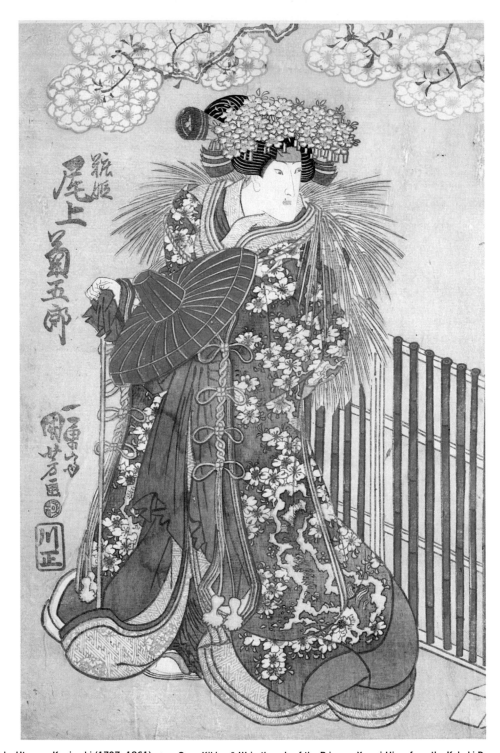

Print by Utagawa Kuniyoshi (1797–1861)
Colour woodblock print, 37.4 x 25.7 cm (14⅞ x 10⅛ in)
• Stiftung Museum, Düsseldorf

Onoe Kikigorō III in the role of the Princess Yosooi Hime from the Kabuki Drama *Love Song at the Snow Line*, 1832. One of the most versatile of actors, Onoe Kikigorō III was among the first actors to perform *kaneru yakusha*, which requires the adaptability to play different characters and gender roles.

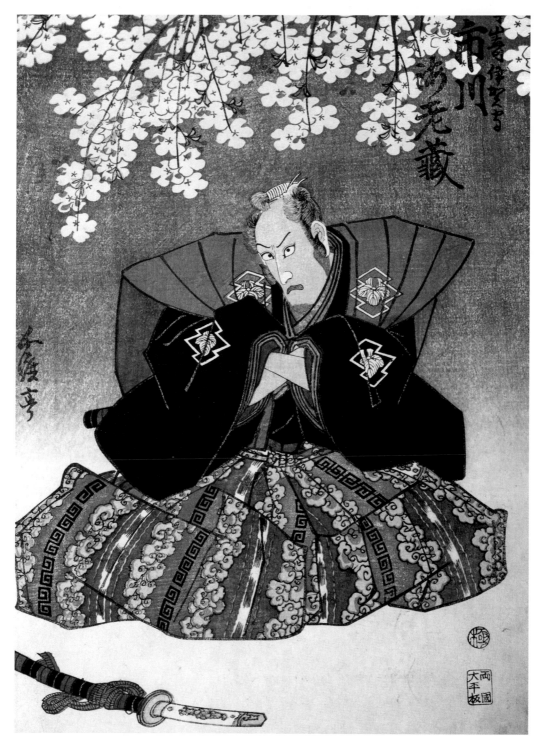

Print by Utagawa Kunisada (Toyokuni III) (1786–1865)
Colour woodblock print

The Actor Ebino playing Sasaki Ipanomori the Samurai, 1839. Traditionally, the samurai wore two swords, known as *daishō*, which literally means 'big-little'. Towards the end of the Edo period, samurai wore fewer weapons in everyday life, but on stage, they were always depicted with both these weapons.

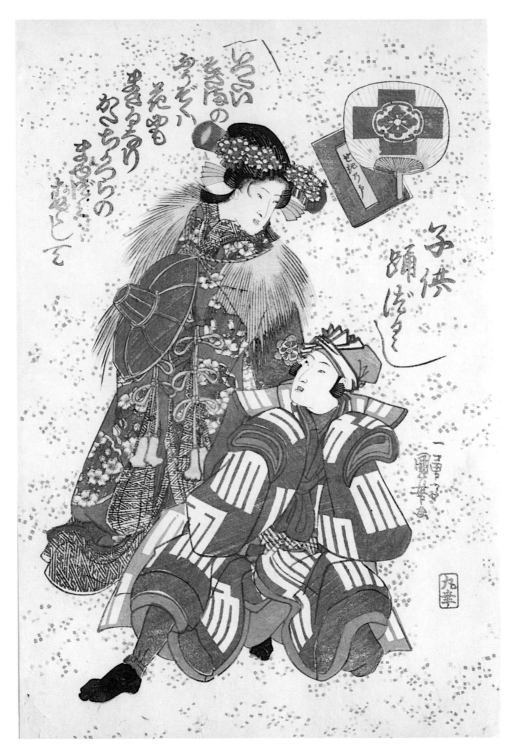

Print by Utagawa Kuniyoshi (1797–1861)
Colour woodblock print, 37.1 x 24.8 cm (14⅝ x 9¾ in)
• Stiftung Museum, Düsseldorf

Imitated scene from the kabuki drama *Love Song at the Snow Line*, *c.* 1840. Despite the fact it is a love story, this kabuki drama is being performed by children, which is unusual in *ukiyo-e*. Kuniyoshi depicted many children in his prints, this one part of a series called 'Children's Games'.

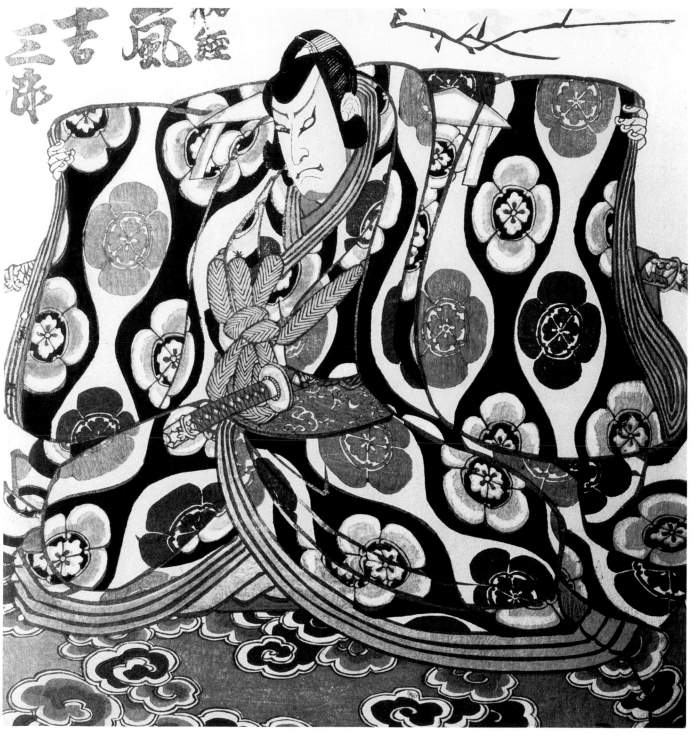

Print by Utagawa Kunisada (Toyokuni III) (1786–1865)
Colour woodblock print, 36.2 x 24.7 cm (14³/₁₀ x 9⁷/₁₀ in)
• Museum of East Asian Arts, Berlin

The Actor Tamizo Onoe, 1841–43. Tamizo Onoe II (1799–1886) was a popular and versatile actor at the Kawarazaki-za, one of the main theatres in Edo. He had a reputation for *haragawari*, or quick costume change.

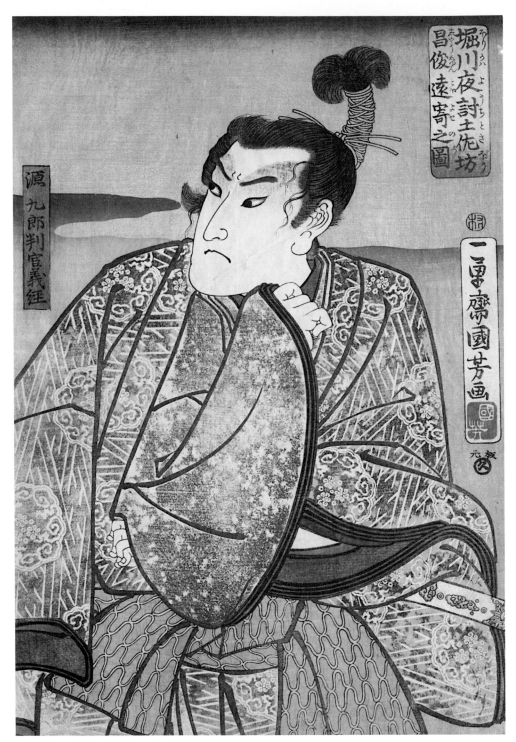

Print by Utagawa Kuniyoshi (1797–1861)
Colour woodblock print, 37 x 25.1 cm (14⅝ x 9⅞ in)
• Stiftung Museum, Düsseldorf

Yoshitsune, Escaped from the Attack on Castle Horikawa, 1844. From the kabuki drama *Night Attack on Fort Horikawa*, this is the character Yoshitsune, possibly the greatest samurai warrior in Japanese history, and immortalized in the literary classic *The Tale of the Heike*.

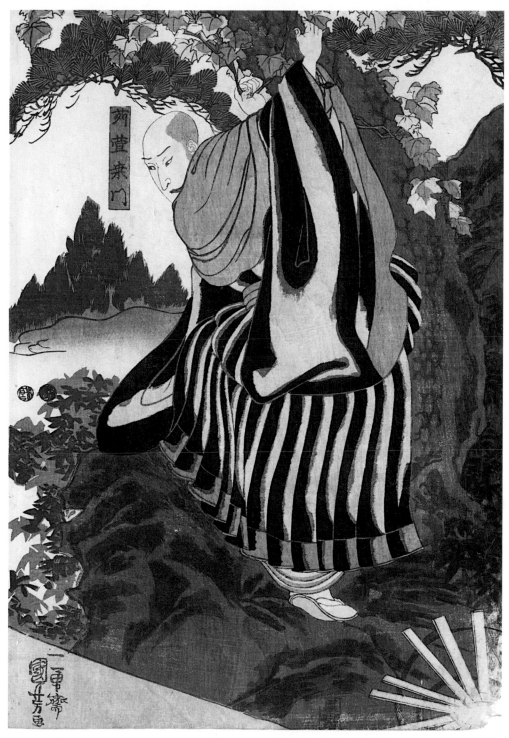

Print by Utagawa Kuniyoshi (1797–1861)
Colour woodblock print, 35.9 x 25.2 cm (14¹⁄₁₀ x 9⁹⁄₁₀ in)
• Stiftung Museum, Düsseldorf

Karukaya: From the kabuki masterpiece *Karukara and his Memory from Kyoshu*, 1847. This image depicts the Buddhist priest Karukaya, who was once a *daimyo* lord and wanted to escape the clutches of his jealous wife. He was eventually discovered by his son, who agreed not to betray him.

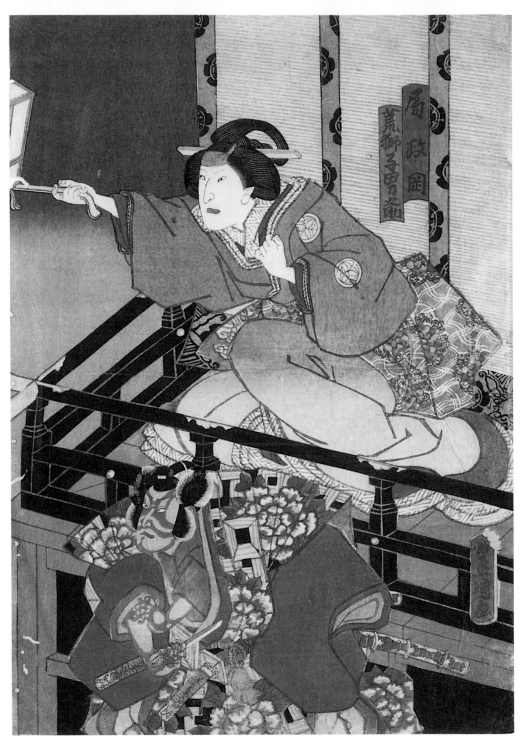

Print by Utagawa Kunisada (Toyokuni III) (1786–1865)
Colour woodblock print, 36.1 x 25.5 cm (14⅕ x 10 in)
• Stiftung Museum, Düsseldorf

Wet Nurse Masaoka and the Faithful Otokonosuke Chasing Nikki Danjo having been Transformed into a Rat. This kabuki drama tells the story of a young prince who becomes head of his clan, his wet nurse Masaoka fearing for his life. The evil Nikki Danjo plots to kill the prince, but is foiled by Masaoka.

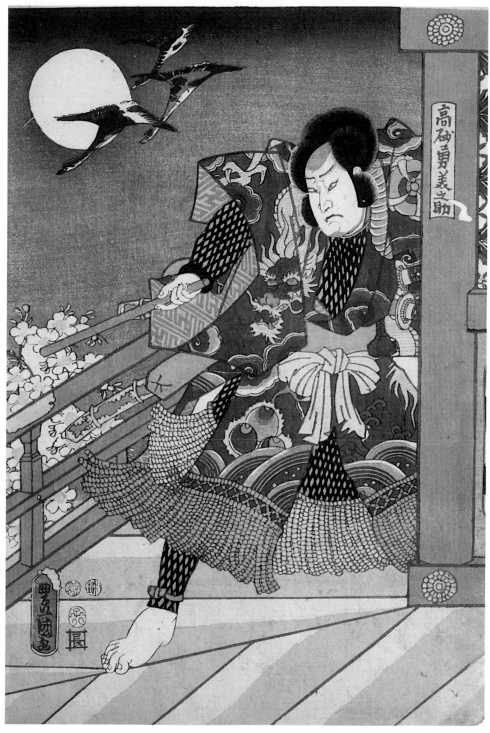

Print by Utagawa Kunisada (Toyokuni III) (1786–1865)
Colour woodblock print, 36.3 x 24.6 cm (14³/₁₀ x 9⁷/₁₀ in)
• Stiftung Museum, Düsseldorf

Arashi Rikan Representing Takasago Yuminosuke, 1852. From the drama *The Heroic Adventures of Jiraiya*, this is a folk hero ninja who can turn himself into a toad by magic. His archenemy is Orochimaru, a master of serpent magic.

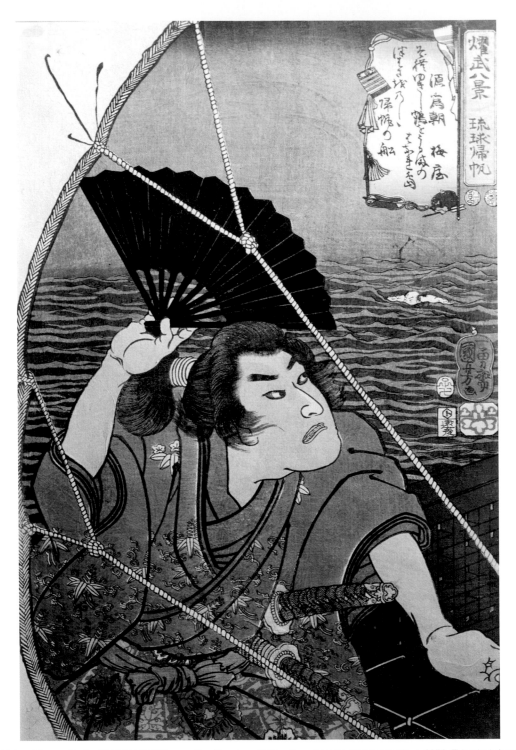

Print by Utagawa Kuniyoshi (1797–1861)
Colour woodblock print, 36.9 x 25 cm (14½ x 9⅞ in)
• Museum of East Asian Arts, Cologne

Hero Tametomo Sailing Home from the Ryukyu Islands, *c.* 1852. This print is from the series 'Military Brilliance for the Eight Views', which depicts military heroes and takes as its inspiration Chinese landscape pictures representing aspects of the day or weather, which Kuniyoshi likened to the heroes' characters.

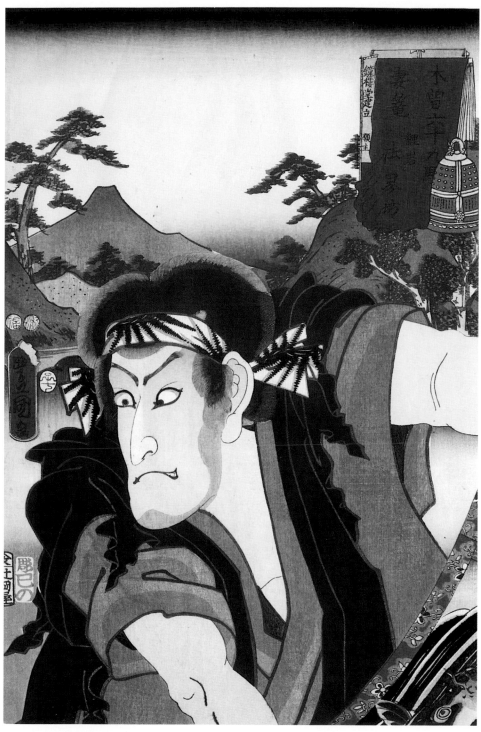

Print by Utagawa Kunisada (Toyokuni III) (1786–1865)
Colour woodblock print, 35.6 x 24.2 cm (14 x 9½ in)
• Stiftung Museum, Düsseldorf

Tsumago: The Monk Hokaibo Collecting Donations for the Bell Tower, 1852. Tsumago is one of the 69 stations of the Kiso Highway. In this image, Kunisada depicts the depraved monk Hokaibo at the station, trying to extract money from the locals to pay for his hedonistic lifestyle by seeking 'donations'.

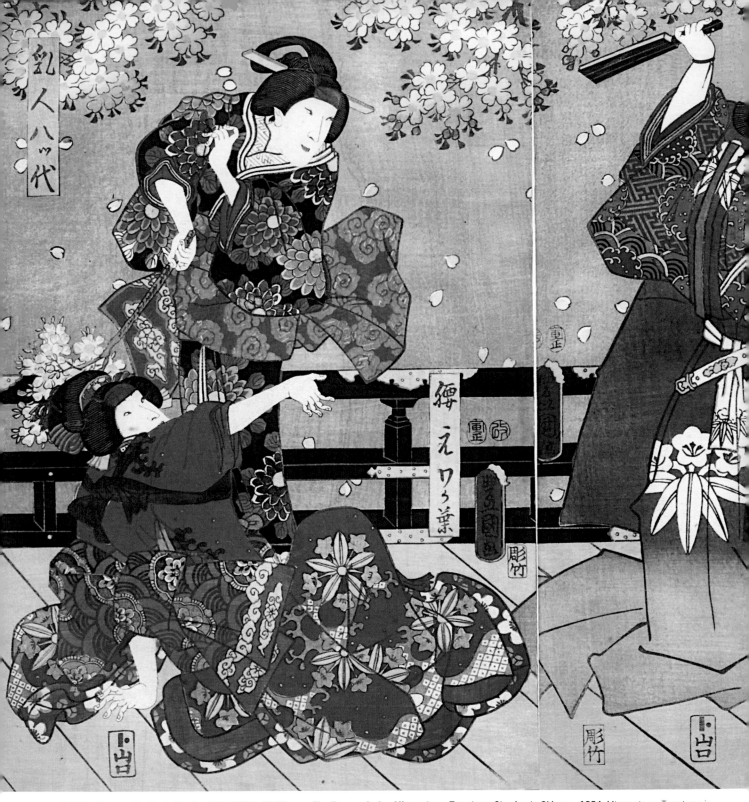

Print by Utagawa Kunisada (Toyokuni III) (1786–1865)
Colour woodblock print, 36.4 x 74.8 cm (14⁷⁄₁₀ x 29⅗ in)
• Stiftung Museum, Düsseldorf

The Famous Archer Minamoto no Tametomo Straying to Okinawa, 1854. Minamoto no Tametomo is depicted in the middle panel, a famous and feared bowman of the twelfth century. Legend has it that he once sank a warship with a single arrow aimed at the hull below the waterline.

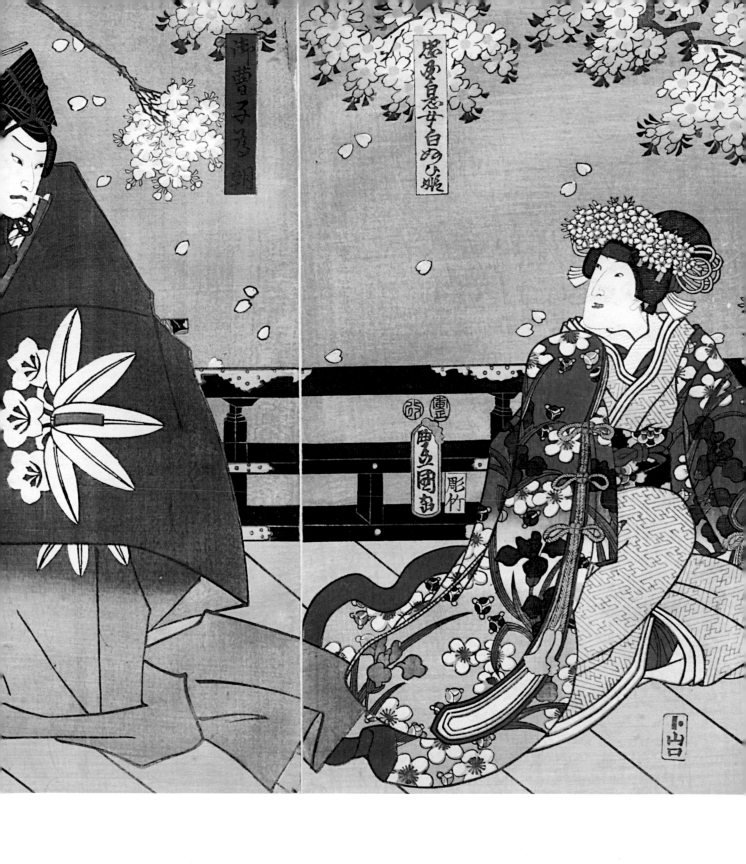

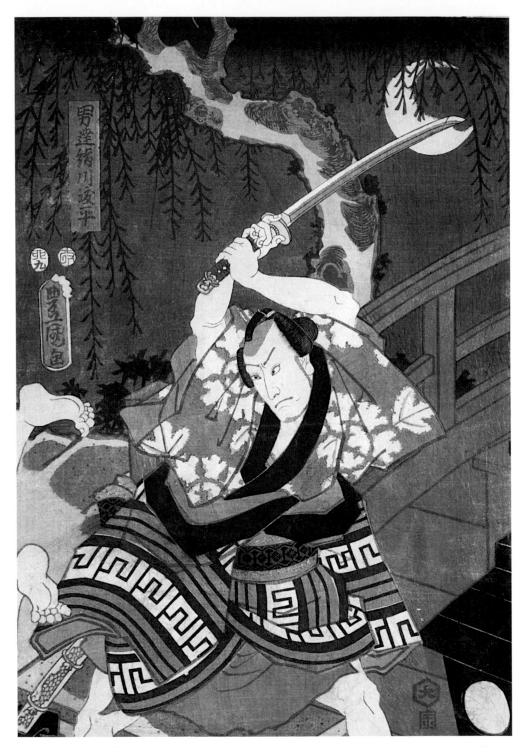

Print by Utagawa Kunisada (Toyokuni III) (1786–1865)
Colour woodblock print, 36 x 25 cm (14⅛ x 9⅞ in)
• Stiftung Museum, Düsseldorf

Bando Hikosaburo IV as the Gentleman Tohei, from the drama *In the Shadows of the Trees a Whiff of a Date*, 1855. This print shows one of the last performances by Bando Hikosaburo IV before he handed his name on to his adopted son in 1856, and continued to act under the name Kamezo I.

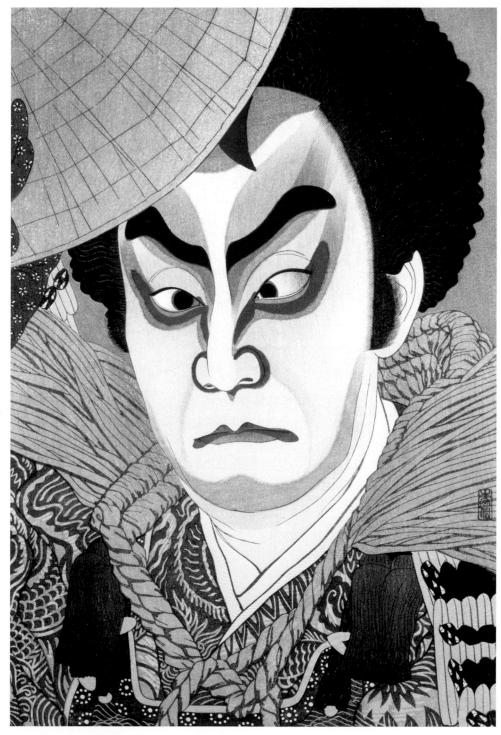

Print by Natori Shunsen (1886–1960)
Colour woodblock print

The Actor Ichikawa Chuska VII aged 66, 1926. This actor is playing the part of Takechi Mitsuhide, based on the true story of the rebel Akechi Mitsuhide. During the Edo period, when the play was first performed, the character's name had to be changed because of censorship laws.

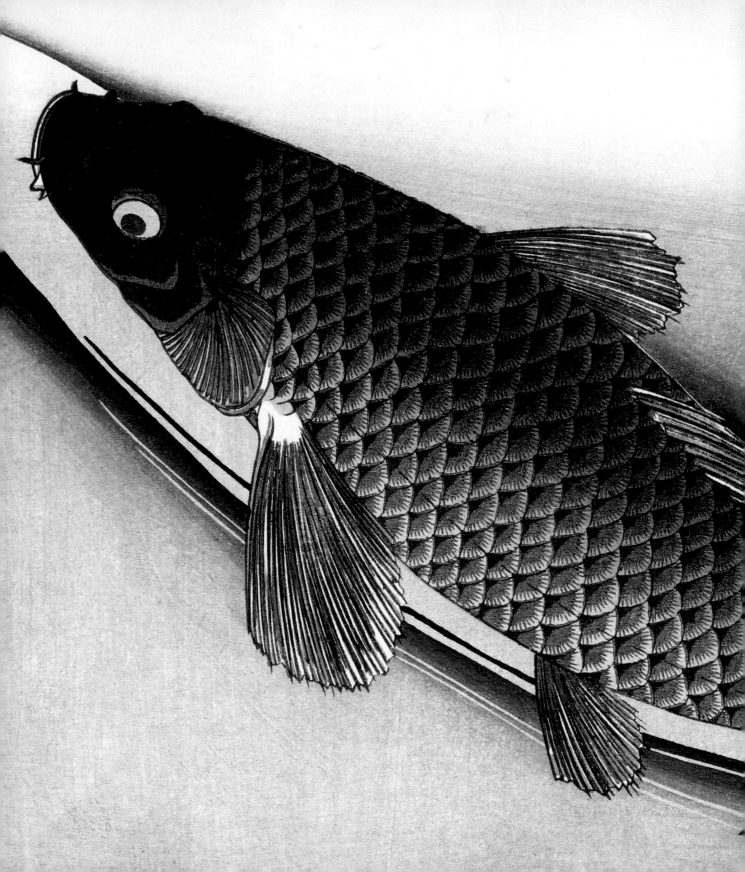

Flora and Fauna

In the latter years of the Edo period, artists sought other motifs for their prints, with new subjects such as flora and fauna extending the style of *ukiyo-e* beyond the depictions of the Yoshiwara district.

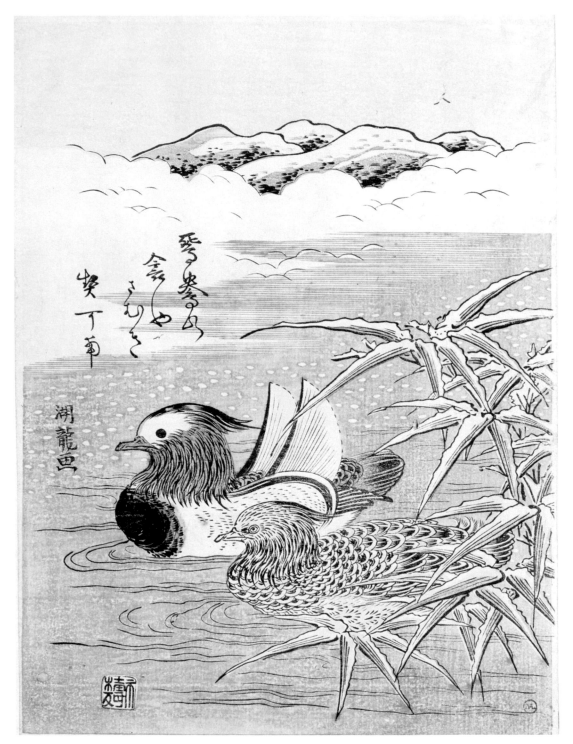

Print by Isoda Koryusai (1735–90)
Colour woodblock print
• Victoria and Albert Museum, London

A Pair of Mandarin Ducks, *c.* **1770.** In traditional Asian culture, the male and female Mandarin ducks are believed to form lifelong couples and are regarded as a symbol of fidelity and loyalty. In some countries, ducks carved out of wood are used in marriage ceremonies.

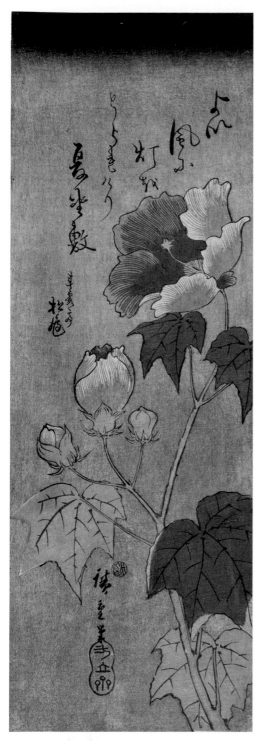

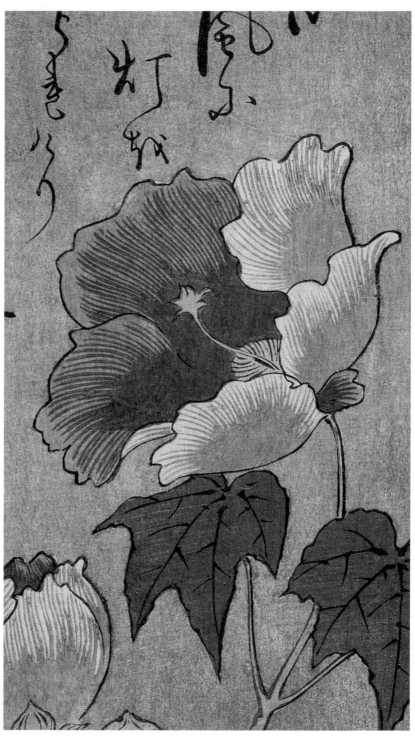

Print by Utagawa Hiroshige (1797–1858)
Colour woodblock print

Flowering Poppies, 19th century. These long, narrow format prints of flora and fauna lent themselves very well as decorative pieces, pasted on to pillars inside Japanese homes of the Edo period. Fortunately, many other citizens collected them in folios for posterity.

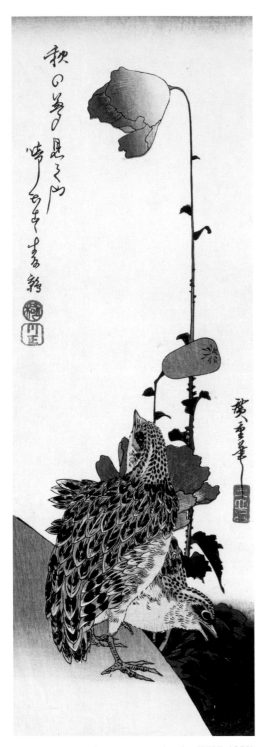

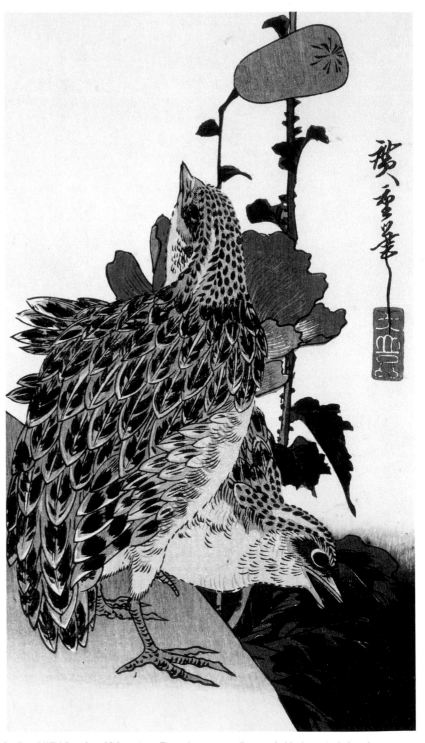

Print by Utagawa Hiroshige (1797–1858)
Colour woodblock print

Quail and Wild Poppies, 19th century. These Japanese quail are probably drawn to their main diet of cereal and grass seeds by the bright red poppies that grow in their midst. The pair shown are probably one of each sex.

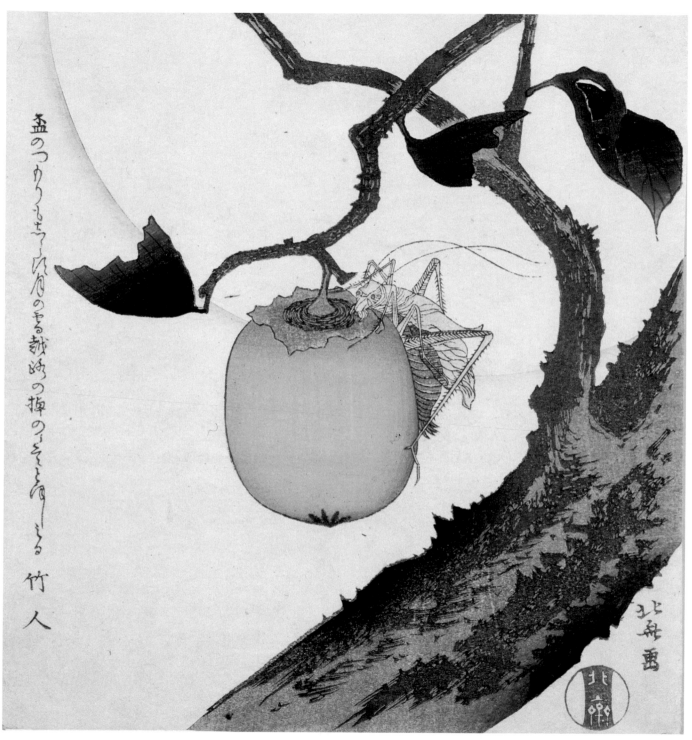

盃のつりもち月の雪越路の掉のそ月る竹人

Print by Katsushika Hokusai (1760–1849)
Colour woodblock print, 20 x 14.5 cm (7⁷⁄₁₀ x 5⁷⁄₁₀ in)
• The Pushkin Museum of Fine Arts, Moscow

Fruit on Branch, 1807. This fruit is probably a persimmon, known in Japan as a *kaki*. It is often to be seen still hanging on the tree after the leaves have already dropped, making it ideal for scavenging crickets.

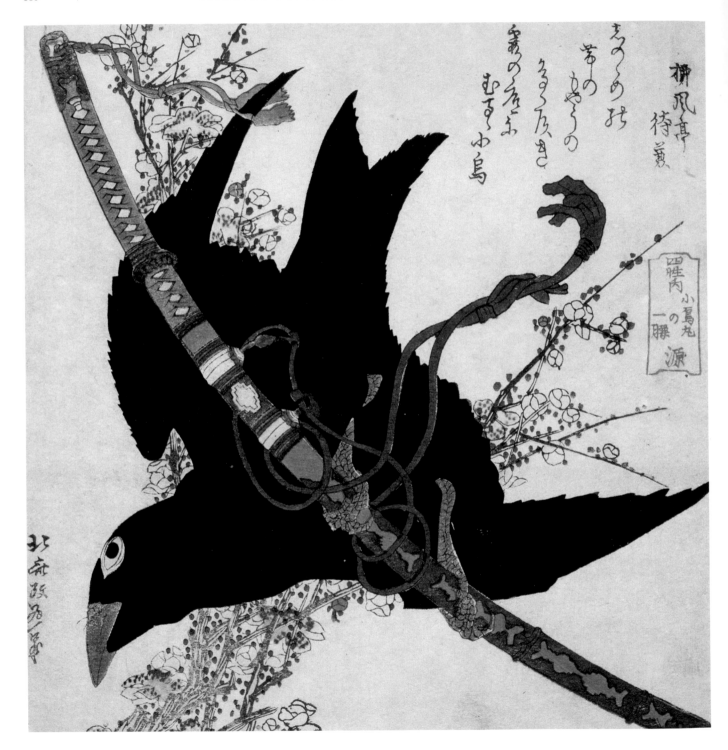

Print by Katsushika Hokusai (1760–1849)
Colour woodblock print
• The Pushkin Museum of Fine Arts, Moscow

Crow Holding Sabre, *c.* 1823. The 'sabre' shown here is actually a katana, as used by the samurai warriors in combat. The crow in Japanese myth is sometimes seen as the intervention of Heaven in earthly affairs.

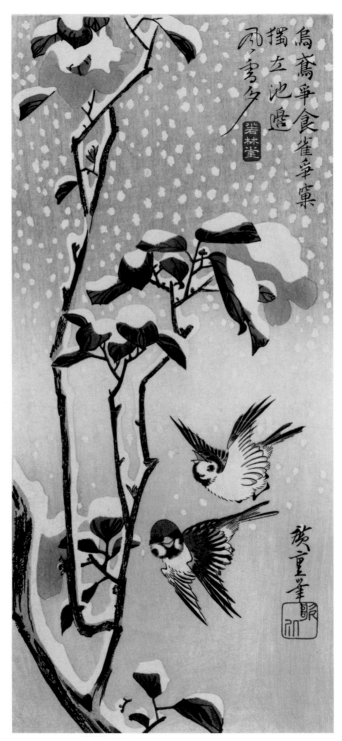

Print by Utagawa Hiroshige (1797–1858)
Colour woodblock print
• The Pushkin Museum of Fine Arts, Moscow

Sparrows and Camellias in the Snow, 1832–34. The camellia is native to Japan and Southeast Asia, and is used in a variety of ways other than floral decoration; the leaves are used in making tea, while the seeds are crushed and used in hair care.

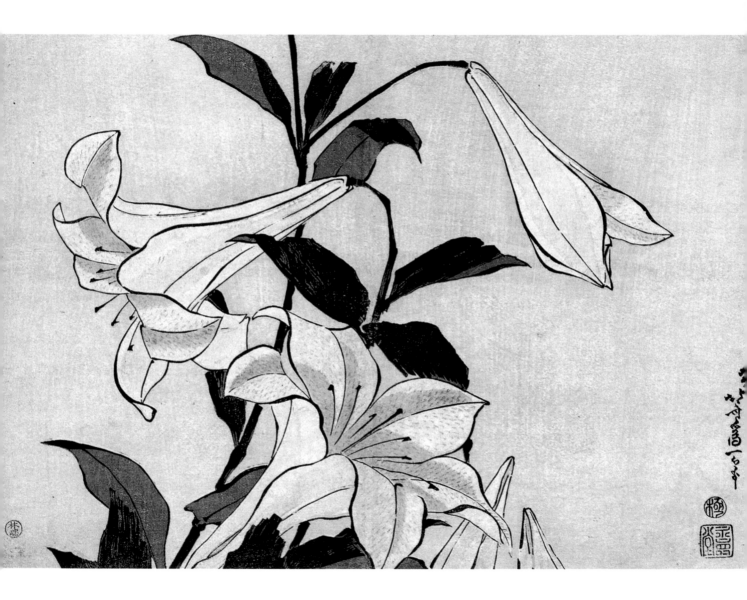

Print by Katsushika Hokusai (1760–1849)
Colour woodblock print
• The Pushkin Museum of Fine Arts, Moscow

Lily Flower, *c.* **1830.** The delicate and feminine quality of these lilies is emphasized by Hokusai's treatment of fine line, and the calm pastel colouring of the flowers is accentuated by the gentle blue background.

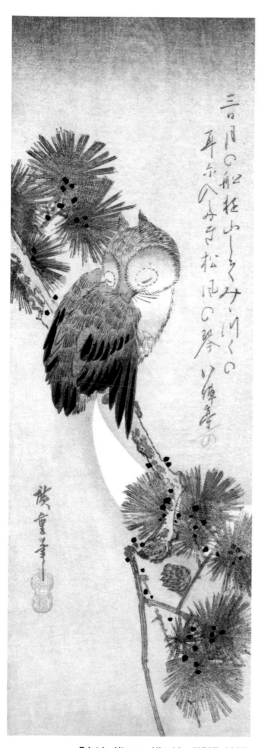

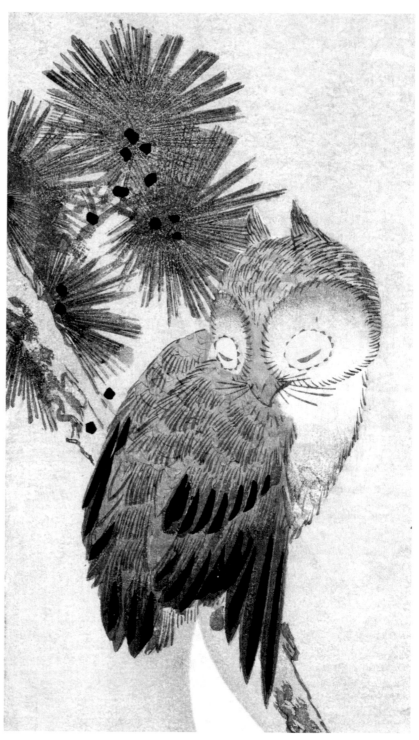

Print by Utagawa Hiroshige (1797–1858)
Colour woodblock print
• 37.4 x 12.4 cm (14⁷⁄₁₀ x 4⁹⁄₁₀ in)

The Crescent Moon and Owl Perched on Pine Branches, *c.* **1830–32.** In Japanese, *fukurou* means owl, and since the word *fuku* means luck, the owl is symbolic of good fortune. This pillar print is likely to have been pasted on the walls of home interiors as a charm.

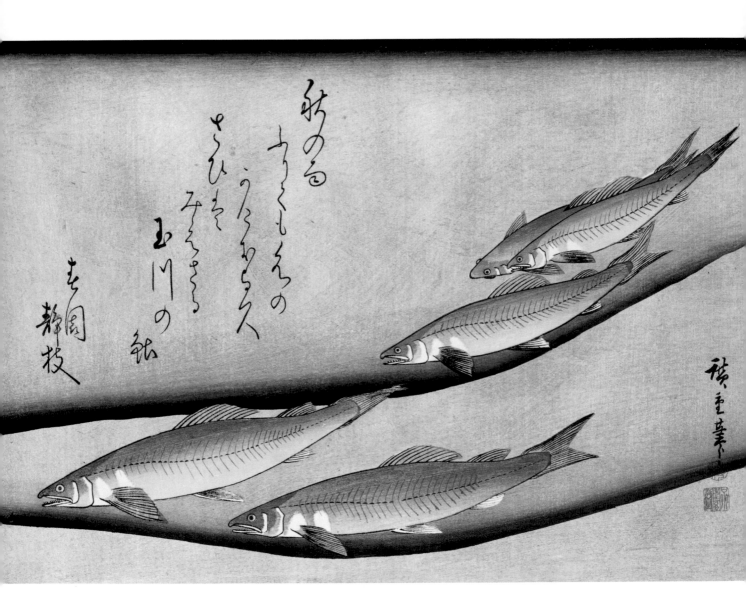

Print by Utagawa Hiroshige (1797–1858)
Colour woodblock print
• 26.2 x 38 cm (10⅗₀ x 15 in)

River Trout: from the series 'Collection of Fish', *c.* **1832.** As an island race, fishing has always been one of the most important traditions in Japan. In the Edo period, samurai, who were forbidden to practise martial arts, began fly-fishing as an alternative.

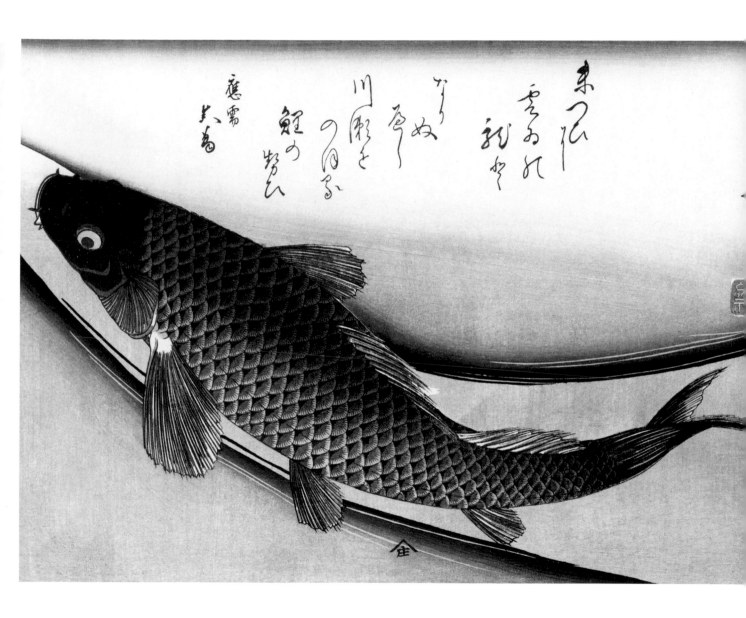

Print by Utagawa Hiroshige (1797–1858)
Colour woodblock print

Carp: from the series 'Collection of Fish', *c.* **1832.** The carp species can be found in both Central Europe and Asia. However, from about 1820, the Japanese began crossbreeding them to enhance their colour so that they could be sold as exotic food. Such varieties are known as koi carp.

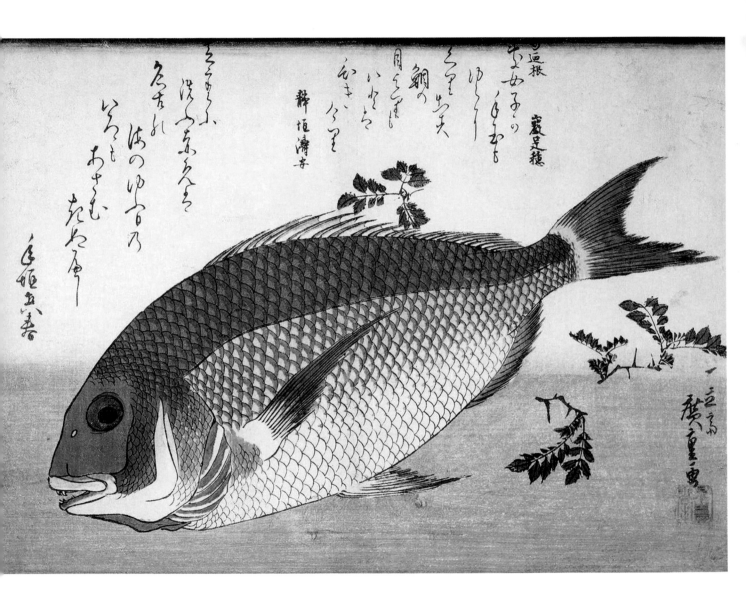

Print by Utagawa Hiroshige (1797–1858)
Colour woodblock print, 25 x 35 cm (9⅞ x 13⅞ in)
• The State Hermitage Museum, St Petersburg

Sea Bream and Sanshō, 1832. The red sea bream, seen here, is a Japanese delicacy and is usually eaten on special occasions such as weddings or New Year festivities. Sanshō is a traditional additive and is known as Japanese pepper.

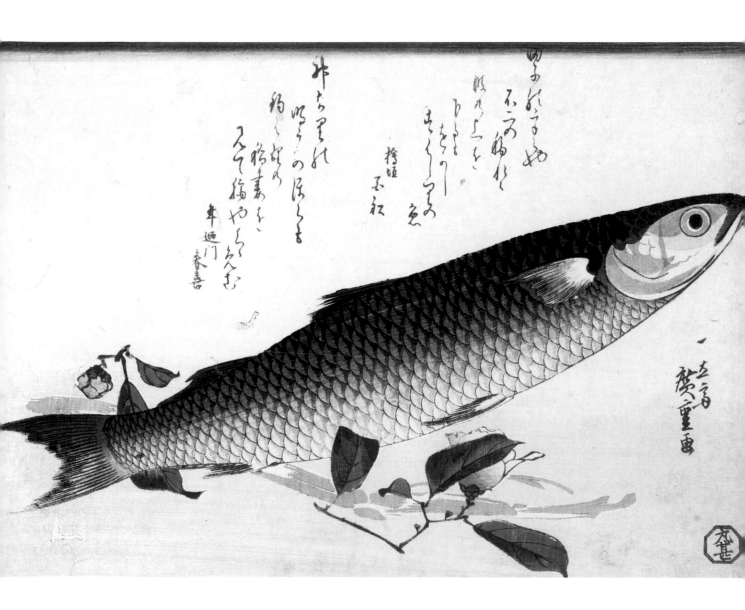

Print by Utagawa Hiroshige (1797–1858)
Colour woodblock print
• Museum of Fine Arts, Boston

Grey Mullet, Camellia and Udo, 1832–33. This print is from Hiroshige's series 'Large Fish'. The bora, or grey mullet, is caught in river estuaries as it enters the sea, but has to be eaten on the same day it is captured, to maintain its flavour.

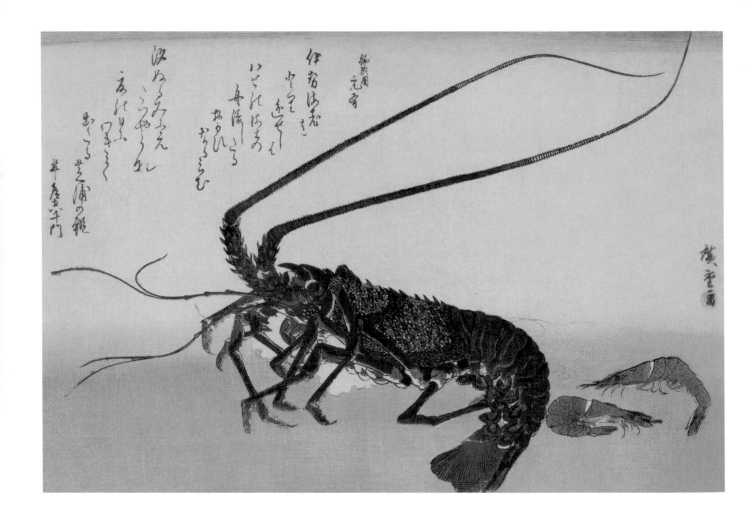

Print by Utagawa Hiroshige (1797–1858)
Colour woodblock print, 25 x 35 cm (9¾ x 13¾ in)
• The State Hermitage Museum, St Petersburg

Shrimp and Lobster, *c.* **1832–33.** This image is another in the series 'Large Fish', although neither the shrimp or lobster are actually fish. Eaten together, the Japanese refer to the dish as *ebi*, meaning 'food for good luck'.

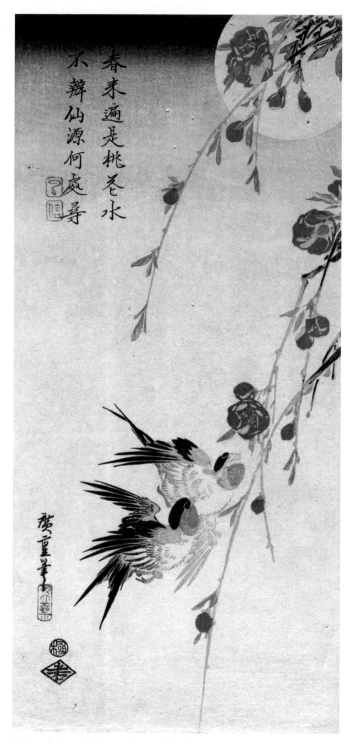

Print by Utagawa Hiroshige (1797–1858)
Colour woodblock print
• The State Hermitage Museum, St Petersburg

Birds, 1833–34. These are swallows, flying against a brightly moonlit evening sky to reach a flowering camellia plant with bright petals and delicate leaves. The swallow is a symbol of fertility, as it migrates to Japan in the spring.

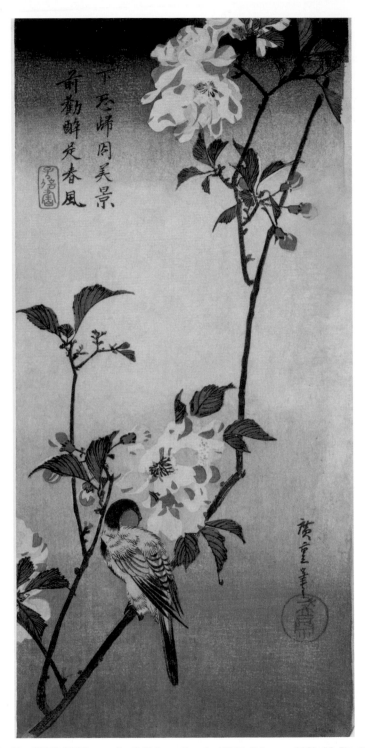

Print by Utagawa Hiroshige (1797–1858)
Colour woodblock print

Small Bird on a Branch of Kaido Sakura, *c.* 1833–38. The cherry blossom shown here is associated with *hanami*, a picnic within the shade of the tree, which became very popular in the Edo period. The cherry blossom flower is symbolic of the transience of life because it does not stay in bloom for long.

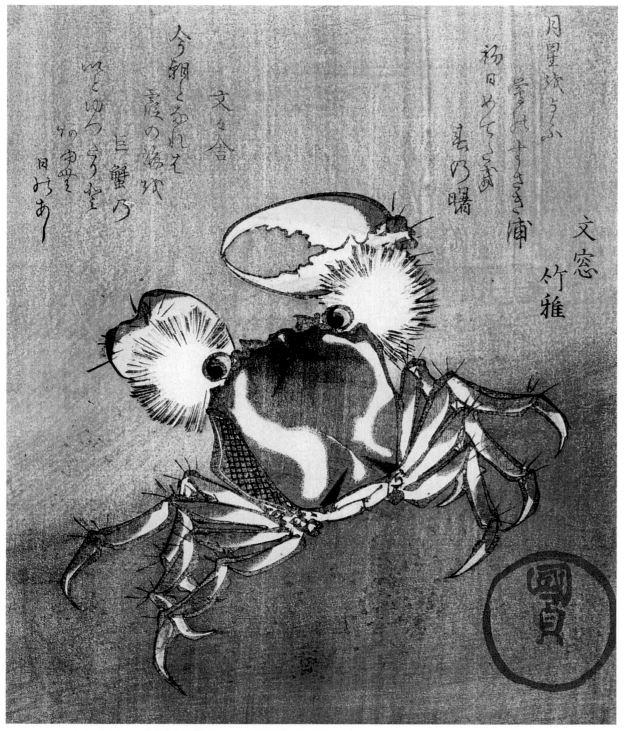

Print by Utagawa Kunisada (Toyokuni III) (1786–1865)
Colour woodblock print
• Private Collection

Crab. Rather like his depictions of kabuki actors, Kunisada gave this crab a human look that is both comedic and threatening. According to Japanese legend, crabs with faces are the souls of drowned samurai warriors.

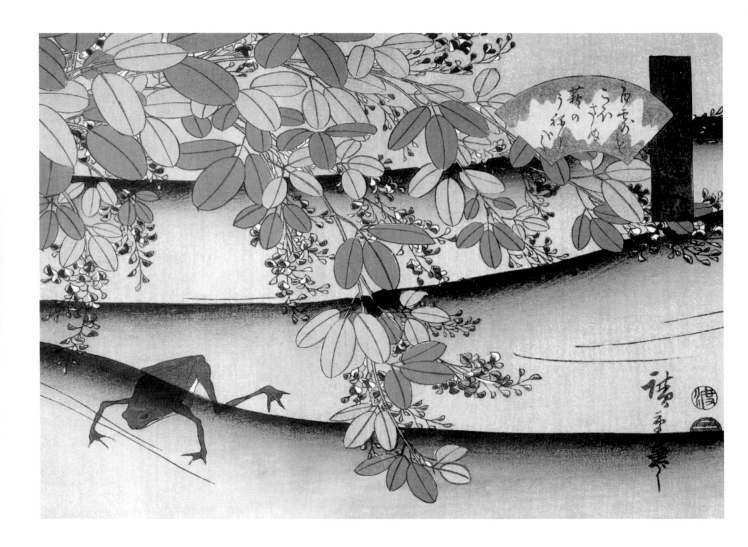

Print by Utagawa Hiroshige (1797–1858)
Colour woodblock print

Clover Bush and Frog. During the Edo period, the main agricultural crop – and thus the main gross domestic product of Japan – was rice, grown in semiaquatic surroundings. Frogs were an important indicator of the conditions and became lucky charms for a good harvest.

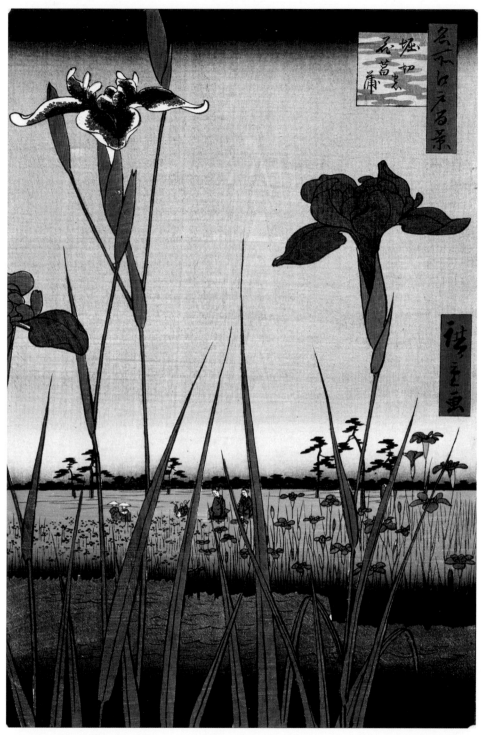

Print by Utagawa Hiroshige (1797–1858)
Colour woodblock print, 39 x 26 cm (15⅜ x 10¼ in)
• The State Hermitage Museum, St Petersburg

Iris Flowers, 1856–58. In this print, the rice harvesters in the paddy field look across the stream in the morning light towards the tall, erect Japanese irises that also depend on wet soil.

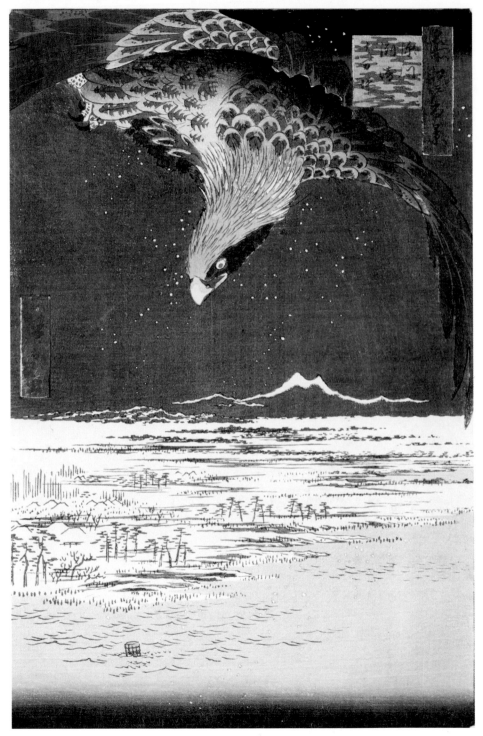

Print by Utagawa Hiroshige (1797–1858) **Jūmantsubo Plain at Fukugawa Susaki, 1856.** The landscape depicted is part of the series 'One
Colour woodblock print, 35.7 x 24.1 cm (14⅒ x 9½ in) Hundred Famous Views of Edo'. Hiroshige has skilfully managed to combine his love of landscape with
• Brooklyn Museum, New York his interest in natural history, using the eagle as a compositional tool.

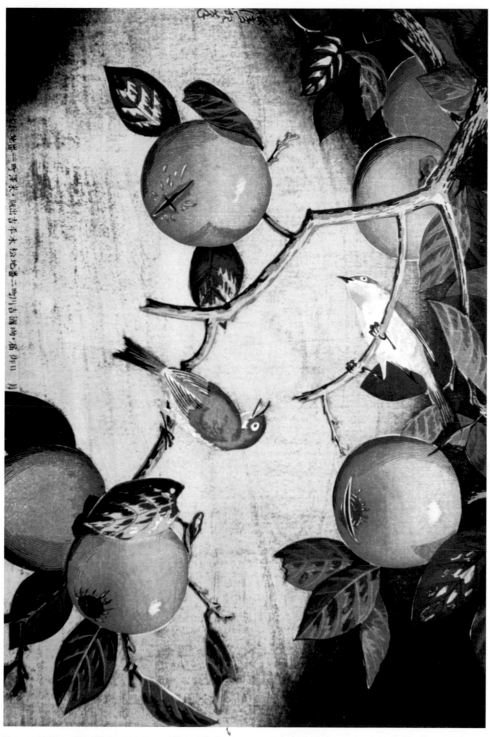

Print by Kobayashi Kiyochika (1847–1915)
Colour woodblock print

Persimmons and White-eye Bird, 1880. The Japanese White-eye, shown here, is an omnivorous creature that eats fruit, nectar and insects. Here, it is depicted in a persimmon tree, whose fruit is actually a berry, despite its size.

Indexes

Index of Works

Page numbers in *italics* refer to illustration captions.

General Index

Page numbers in *italics* refer to
illustration captions.